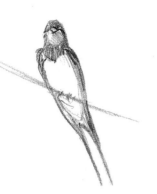

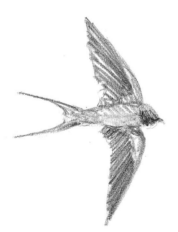

First published in great Britain 2011
A&C Black Publishers
36 Soho Square
London W1D 3QY
www.acblack.com

ISBN: 978-1-4081-3448-1

Publisher: Colette Hanicotte
Editor: Corinne de Montalembert
Page design: Florence de Maux
Proofreader : Madeleine Biaujeaud
Photography : Nord Compo
Production: Anne Reynaud
Photographs pages 6-7 : Copyright Library of the Museum of Natural History, Paris 2009, Panel by Adolphe Millot :
photo by O. Ploton@Archives Larousse
English text layout: Susan McIntyre
Translation: Alexa Stace
Assistant Editor: Ellen Parnavelas

This book is produced using paper that is made from wood grown in managed, sustainable forests. It is natural, renewable and recyclable. The logging and manufacturing processes conform to the environmental regulations of the country of origin.

Printed and bound in China.

DRAWING NATURE

AGATHE RAVET-HAEVERMANS

A & C Black • London

To my mother, Marie-Claire Ravet, artist, for her very particular way of looking at things.
And to my grandparents, in memory of some marvellous nature trips and potatoes baked in the fire…
not forgetting the frogs, snakes and all that I was able to catch and hide in my pockets…

Acknowledgements:
I particularly like to thank Alix Delalande for his great help, encouragement
and numerous corrections to this book!
My husband, who still supports me with all 'my little marvels' carefully
kept in boxes or in the freezer, and which will all be drawn one day…

I thank Allain Bougrain Dubourg for his preface.
I thank also Jeane Meunier, draughtsman in the Museum menagerie,
for all his encouragement and good advice.

And all my suppliers of feathers, nests, insects and advice: Véronique and Frédéric Haevermans,
Marie-France Rossard, Marion Guillaume, Nathalie and Michael Foret, Emmanuel Delfosse,
Françoise Pilard, Daniel Taulet, Marie Molet, Martine Gazelle, Nadine Grandcollot, Karg and
the ornithologists of Chèvreloup and of the ecology group, Jacqueline Jousse, Claude Barreau,
Claude Bourgine, Michel Masson and Jacqueline Candiard.
Denis Lamy, sciences historian and Françoise Bouazzat, responsible for the iconography
of UMR 7205 at the Museum.
Professor Gérard Aymonin for his passion for botanical history.

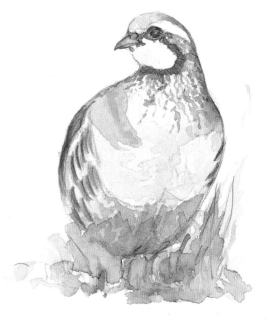

Foreword

Nature for me is a real source of inspiration. I like to take time to look at it and observe it in all its guises. Nature always amazes me with its beauty and variety; every day, in every season, it offers an infinite variety of subjects to draw.

This passion naturally led to my profession as botanical draughtsman at the National Museum of Natural History, Paris. However, that doesn't stop me sketching and painting my dear little insects with such pleasure! Through my instruction in nature drawing I am trying to teach a technique, but above all a way of looking at nature and at the same time respecting it.

In this book you will find practical advice and hints on how to sketch in the open, with the help of different techniques for dry and wet sketches, quick studies or more finished drawings. You will learn how to make a quick sketch just to capture the essentials, how to hold the brush to underline the hollow shape of a foxglove flower, how to bring out the texture of cherry tree bark, how to mix colours, apply them, paint shadows and many other things. You will learn how to make what you see come alive, and achieve the essence of nature drawing: to transcribe your passionate view of nature.

Contents

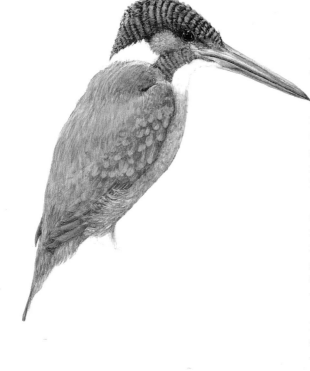

Preface

Agathe Haevermans demonstrates to us the improbable marriage between an artist's drawing and scientific rigour: she is a scientific draughtswoman.

This unusual occupation established its pedigree with the explorers who scoured the planet in search of discoveries. Without a digital camera they had to show great rigour when rendering reality on to paper. Certainly John James Audubon, one of the masters of this art, had to compromise sometimes, but he had the merit of integrating surroundings and movement into his illustrations. His works are today among the most expensive in the world. A happy fact which proves that at the beginning of the 21st century the brush can rival high technology.

Haevermans perpetuates this tradition with a remarkable talent. Her merit shows not simply through the sensitivity of her fingers, but above all by her capacity to live in symbiosis with nature. She was aware of her vocation from childhood. Horrible insects fascinated her. She captured and observed a grass snake, a wall lizard and a green tree frog. She even went so far as to keep reptiles in her bedroom, and was thrilled when they reproduced. With age, she understood the fragility of living things, while circumstances led her to express her passion through illustration.

Like her illustrious predecessors at the National Museum of Natural History, Paris she takes part in assignments. Watercolours and Indian ink take her from Guyana to Madagascar, or from South Africa to the Seychelles. These exciting journeys, which nevertheless demand a lot of determination, since the work is both physical and meticulous, surely allow her an escape. For otherwise, Haevermans is always increasing her artistic activities. She has to organise botanical displays, scientific and descriptive, from herbs to living plants, she contributes to scientific publications, draws new species and finally, she tries to get the message of illustration to a wider audience. Thus we find her giving public courses at the Museum in botanical and zoological watercolours. At the same time, she reveals how crucial it is to take time to observe, to better transcribe. She combines a rigorous scrutiny with emotional capacity.

Her latest work, *Drawing Nature*, invites us to enter into the secrets of her art. Openly she offers to share both her emotions and her experience. Here and there her advice reminds us of the respect owing to the objects being sketched. A delightful stroll in the country of feeling and of talent. Haevermans shows us that the most humble bouquet can become exotic as long as one observes it with respect and with attention. A splendid way of paying service to our fragile biodiversity.

Allain Bougrain Dubourg

History

Early man sought to represent nature around him, particularly the animals he hunted, or perhaps worshipped. The magnificent rock paintings that have been preserved are witness to this ancestral art, as much as anything produced today. The technique goes as far as using and exploiting the natural contours of the rock to bring out the contours or certain parts of the animal's body. In every age, man has used what was at hand to create, using bark, rocks, skin and paper as a surface; earth, minerals, vegetables and later synthetics as pigments.

The idea of illustrating the world, and having as faithful as possible a representation of it, endures so long as the techniques of nature illustrations continue to evolve over the centuries, multiplying the processes of reproduction.

In the Middle Ages, it was mostly the church that was in charge of manuscripts and illustrations. They were aware that it was important to draw from nature, not to be content with a simple written description, or to reproduce an image found in another work, thus creating some fine chimeras.

The Renaissance was a period of great discoveries, of scientific collections, and of the creation of cabinets of curiosities. Interest was growing in understanding the natural sciences. Nature illustrations played a great part in this more reflective knowledge of the world, understanding, describing and making inventories. The invention of the microscope in 1650, allowing infinitely small observation, amplified this movement.

This enthusiasm for natural sciences and an understanding of the world inspired the great scientific explorations of the 18th and 19th centuries. Scholars and explorers brought back from their expeditions descriptions, and a large number of illustrations made on the spot, to complete existing knowledge. These expeditions enabled spectacular advances in the field of science.

A naturalist is a scientist whose object of study is nature – a vast subject which he endeavours to record, classify and describe both in words and by illustration. The most exact possible representation of the surrounding world is fundamental to the work of the naturalist.

Some scholars made their own illustrations, such as the botanist traveller Joseph de Jussieu or Georges Cuvier (1769-1832), founder of palaeontology and one of the fathers of comparative anatomy. Artists also became explorers, taking part in study voyages.

Sketch by Joseph de Jussieu (1704-1779), a French botanist. This nasturtium, sketched in ink and coloured in watercolours on the spot, is beautiful. It shows the details which enable a precise description while retaining the live, natural appearance of the subject.

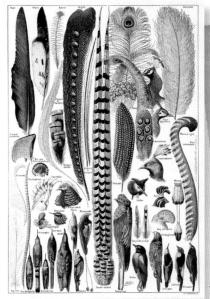

1

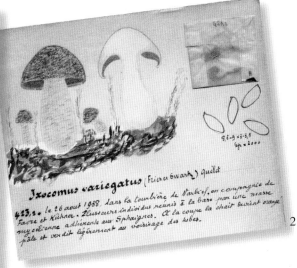

2

Ixocomus variegatus (Swartz) Quélet

423,20 le 26 aout 1958, dans la tourbière de Narlief, en compagnie de
Favre et Kühner. Plusieurs individus réunis à la base par une masse
mycélienne adhérente aux Sphaignes. Et la coupe la chair devient orange
pâle et verdit légèrement au voisinage des tubes.

Indeed, these great nature explorers discovered animals so exotic that it was impossible to describe them in words. Would you be able to visualise a duck-billed platypus or a kangaroo if you had never seen one? A drawing, an important visual aid, also serves as a description. It allows a better diffusion of scientific ideas. It is an international means of communication which frees us from linguistic barriers.

Despite the appearance of photography, drawing remains an excellent illustration technique. Scientific drawing is also a complementary form of analysis, indeed more effective, than a photograph. It links the art and technical rigour of the illustrator with scientific analysis. The photograph, which freezes one given moment, has not supplanted the drawing, which itself is a translation, an interpretation, a rendered observation of reality. A drawing allows us to draw the attention of the reader to the essential points quickly and effectively.

1 Adolphe Millot (1857-1921)

Professor of drawing at the Museum, specialising in the illustration of animals and vegetation. The successor of Pierre Larousse, founder of the first *Dictionary of the French Language* at the time of the first *nouveau Larousse illustré* (1897-1904), then of the *Petit Larousse illustré*, called on Adolphe Millot.

The illustrations combine the talent of a draughtsman with the knowledge of a scientist.

2 Georges Metrod (1883-1961)

Teacher of mathematics at the lycée in Champagnole (Jura), and a mushroom specialist. His collection consists of a systematic treatment of specimens accompanied by drawings and notes, often more 'readable' than the dry specimens that have lost their shape, colour and smell, criteria necessary to identify mushrooms.

Numerous artists still contribute to the enrichment of the world of natural art. The National Museum of Art History in France continues this tradition, regularly adding to its collection of parchments. At the same time, scientific draughtsmen illustrate the articles and publications of those explorers who leave for the four corners of the earth, finding new species every year.

Some famous illustrators and learned travellers

Thomas Bewick (1753-1828) English wood engraver and ornithologist
John White (c 1540-1593) English artist and one of the early colonists who sailed to North Carolina 1585 and made numerous nature studies
William Curtis, publisher of Flora Londinensis 1777-98, including prints by botanical artists such as James Sowerby, Sydenham Edwards and William Kilburn
Elizabeth Blackadder, famous contemporary Scottish painter and printer, specialising in landscapes, flowers and cats
Nicholas Robert (1610-1684) botanical painter and engraver
Anna Maria Sybilla Merian (1647-1717) German naturalist and illustrator, the first woman, in 1705, to draw illustrations in Surinam.
Claude Aubriet (1665-1742) painter who accompanied Tournefort on his scientific expedition to the Levant, between 1701 and 1702.
Madeleine Françoise de Basseporte (1701-1780) miniature painter and botanical painter
Sydney Parkinson (1745-1771) artist who took part in the expeditions with James Cook.
Pierre-Joseph Redouté (1759-1840) French illustrator and botanist, and **Henri-Joseph Redouté** (1766-1852) illustrator who took part in Bonaparte's Egyptian campaign (1798-1801).
Gérard van Spaendock (1746-1822) Dutch painter-engraver
Nicholas Huet (1770-1830) French naturalist painter and engraver
Charles Alexandre Lesueur (1778-1846) French naturalist and artist
John James Audubon (1785-1851) American painter of French origin who painted birds in their natural habitat.
John Gould (1804-1881 British ornithologist and naturalist who showed in the same study the bird with its nest, its young and its habitat.
John Gerrard Keulemans (1842-1912) Dutch illustrator specialising in bird drawings

Contemporary illustrators

Robert Bateman, Canadian animal painter
Carl Brenders, Belgian naturalist illustrator
Jacqueline Candiard, French artist and illustrator specialising in botany
Gillian Condy, botanical artist, Pretoria Herbarium, South Africa
Kim Donaldson, African naturalist illustrator
Christophe Drochon, French animal illustrator
Ann Farrer, English illustrator specialising in botany, Kew Gardens, London
Jacky Jousson, French naturalist illustrator
Liz McMahon, naturalist illustrator, South Africa
Federico Gemma, Italian naturalist illustrator
Margaret Mee (1909-1988) English naturalist illustrator and first woman to explore the Amazon
Anita Walsmit Sachs, Dutch botanical illustrator
Billy Schowell, English botanical illustrator

And many others, for there a lot of good naturalist illustrators

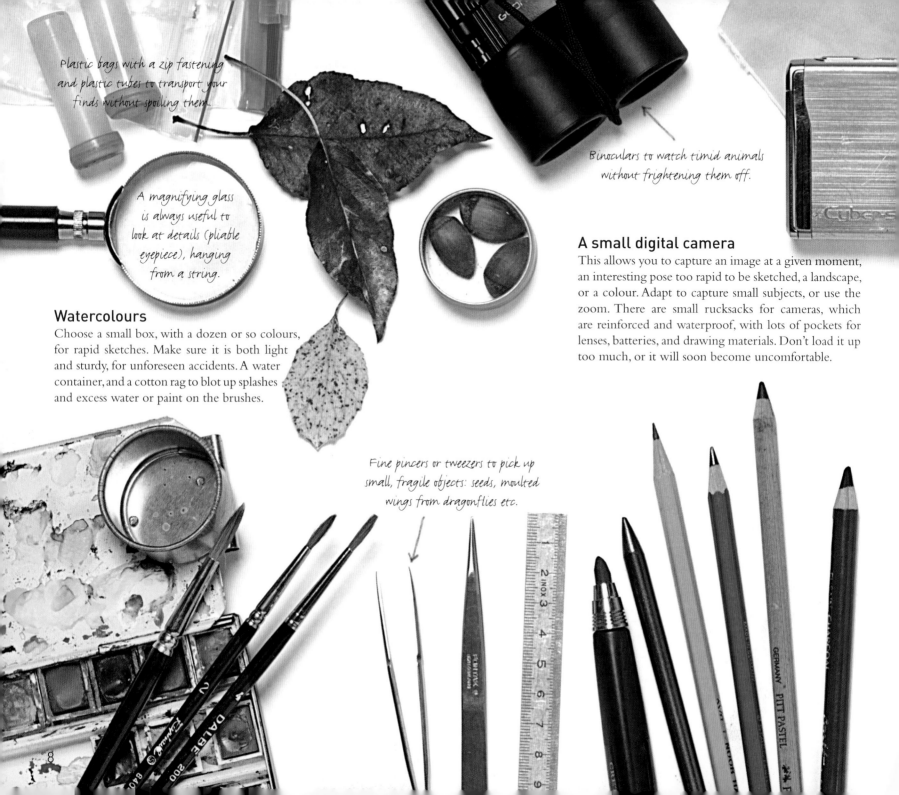

Plastic bags with a zip fastening and plastic tubes to transport your finds without spoiling them.

A magnifying glass is always useful to look at details (pliable eyepiece), hanging from a string.

Binoculars to watch timid animals without frightening them off.

Watercolours

Choose a small box, with a dozen or so colours, for rapid sketches. Make sure it is both light and sturdy, for unforeseen accidents. A water container, and a cotton rag to blot up splashes and excess water or paint on the brushes.

A small digital camera

This allows you to capture an image at a given moment, an interesting pose too rapid to be sketched, a landscape, or a colour. Adapt to capture small subjects, or use the zoom. There are small rucksacks for cameras, which are reinforced and waterproof, with lots of pockets for lenses, batteries, and drawing materials. Don't load it up too much, or it will soon become uncomfortable.

Fine pincers or tweezers to pick up small, fragile objects: seeds, moulted wings from dragonflies etc.

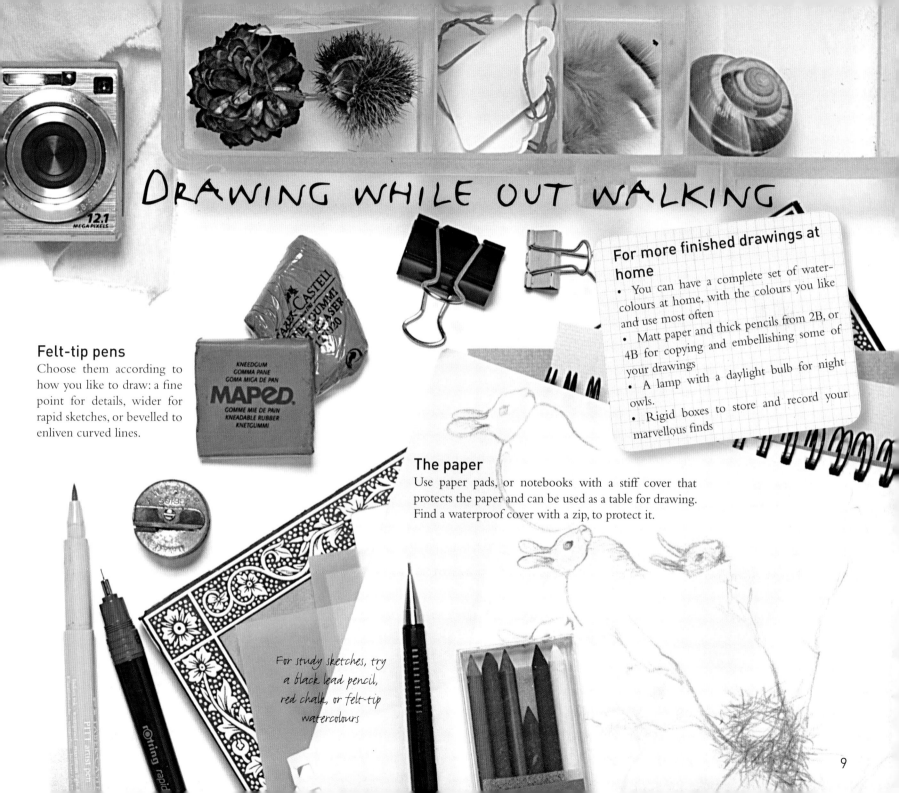

DRAWING WHILE OUT WALKING

Felt-tip pens

Choose them according to how you like to draw: a fine point for details, wider for rapid sketches, or bevelled to enliven curved lines.

The paper

Use paper pads, or notebooks with a stiff cover that protects the paper and can be used as a table for drawing. Find a waterproof cover with a zip, to protect it.

For more finished drawings at home

- You can have a complete set of water-colours at home, with the colours you like and use most often
- Matt paper and thick pencils from 2B, or 4B for copying and embellishing some of your drawings
- A lamp with a daylight bulb for night owls.
- Rigid boxes to store and record your marvellous finds

For study sketches, try a black lead pencil, red chalk, or felt-tip watercolours

9

Shapes and volume

The three basic shapes – the sphere, cylinder and cone – are found in almost every living thing. Recognising these shapes enables you to visualise volume much more easily.

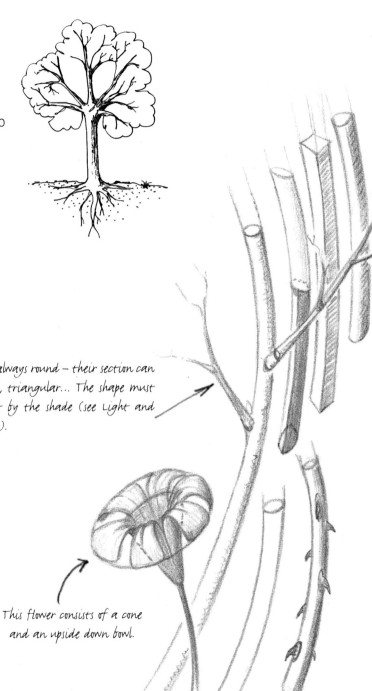

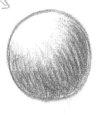

The sphere is used to form heads, bodies of birds, some floral buds...

The cone is often the basis of numerous flowers, or the beak of a bird.

The cylinder enables you to draw a stem, a branch, the body of a snake...

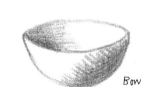

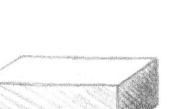

Bowl

Stems are not always round – their section can be square, oval, triangular... The shape must be brought out by the shade (see Light and shade, pp.12-13).

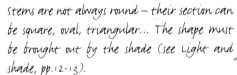

Mammals, such as goats or foxes, appear as cubes or parallelepipeds.

This flower consists of a cone and an upside down bowl.

A mushroom is composed of an upside down bowl and a cylinder for the stalk.

The bowl is perfect for birds' nests or the corolla of a flower.

Assembling and organising shapes

Several shapes can be linked in the structure of an animal or a plant. The mushroom is composed of a bowl upside down with a cylinder for the stalk. A bird is composed of a sphere for the head and and an egg shape for the body.

Certain flowers, such as the pansy, fit well into a circle.

This bird is composed of two egg-shaped forms.

This egg shape is often found in fruit or birds' bodies...

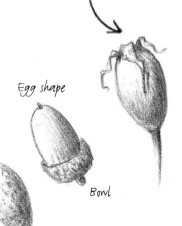

Egg shape

Bowl

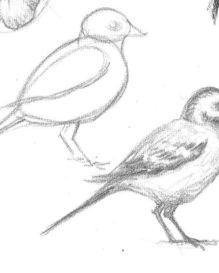

see The wild blackberry, p.54.

11

Light and shade

By convention, the light in a drawing comes from top left, so the shadow is on the right, on the opposite side. In nature, light comes from different directions and changes with the sun as it moves during the day. Only artificial light can stay the same indefinitely.

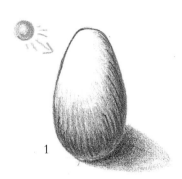

1

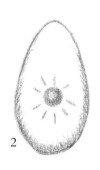

2

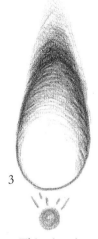

3

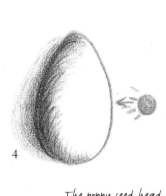

4

Different kinds of shadows

You have to distinguish the shadow particular to the object – the part which is not exposed to direct light – from the shadow projected by the object onto something else – the cast shadow. An egg, according to how it is illuminated, will have several different shadows of its own, and the cast shadows are also all different.

1 If the egg is upright, the light coming from above left. It stops the light, and the transferred shadow is then at bottom right. It is the situation which best brings out the volume of an object, which is why it is used by convention in scientific drawings.

2 If the light comes from behind you when looking at the egg, it has no cast shadow and very little volume. This situation is comparable, in nature, to the midday sun which illuminates perfectly from above. It is best to avoid this light, which flattens the relief.

3 A low-angled light produces a more extended transferred shadow, which diminishes gradually. This happens every morning and evening, with the rise and setting of the sun. It is a good, warm light, but it modifies colours and the perception of shapes.

4 With side light, the egg takes on body and the cast shadow is medium in size. The egg is less deformed than with the low-angled light. Everything with volume will be highlighted if you position the shadows well.

The poppy seed head at the end of the stem, standing up, creates a cast shadow. The nearer it is to the sun, the more the shadow is short and dark.

The stem is a little rounded and does not completely touch the earth. The shadow is more diffused and not so dark, but it continues up to the part that lies on the ground.

Cast shadows

Showing a cast shadow enables you to position a subject and give it consistency and body. Look at these drawings of leaves.

1 The leaves of the same uniform colour look flat, in spite of being one on top of another – they don't have any depth.

2 With the same colour and different quantities of paint, we can create distinct areas with more or less light. To best show the more shaded areas, it is enough to go over again with the brush, with the same amount of paint, to give it more body.

3 By adding a cast shadow the leaves seem to stand out from the paper and have even more volume. Visually, the different elements stand out from each other, thanks to the succession of areas of light, shade and cast shadows.

In a composition, you must make sure that the light is always on the same side. In a bouquet, for example, it is important to decide which side the light is coming from so that the ensemble is coherent, even if the flowers are drawn in several stages. The shadows must not indicate midday on one flower and 6pm on another!

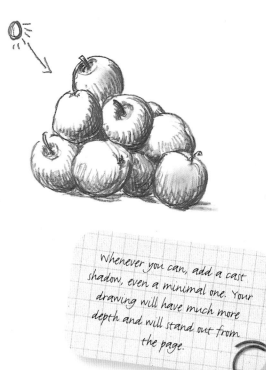

1

2 Cast shadow

3 More extended cast shadow, bigger and more diffused.

4 Cast shadow reduced because the leaves are near each other.

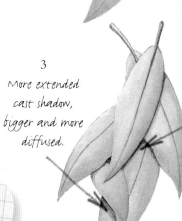

Whenever you can, add a cast shadow, even a minimal one. Your drawing will have much more depth and will stand out from the page.

13

Colour and its gradations

The chromatic circle enables us to see the colour spectrum easily. It is composed of three primary colours: red (magenta), yellow and blue (cyan), which are the basis of all colours.

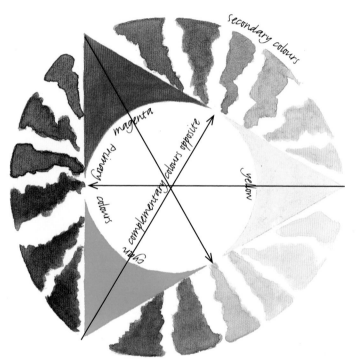

The chromatic circle can be divided into an infinite number of intermediate colours.

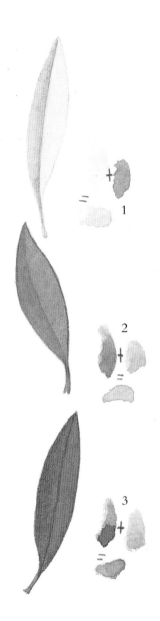

Primary and secondary colours

The primary colours cannot be created, but can be mixed with each other. Two primary colours produce a secondary colour: green, orange and violet.

Complementary and opposite colours

To find the opposite complementary colour, all you have to do is choose the one opposite on the chromatic circle. This complementary colour can be used to create a shadow that looks natural. Thus as the complementary opposite colour to yellow is violet, a little touch of violet in a lot of yellow, with a lot of water, will give a shadow of the same tone. For cyan, make the shadow with a little touch of orange, and for magenta, with a little touch of green.

Hints and tips on applying colour

1 Apply paint quickly, so as not to leave a mark when starting again.

2 Don't saturate the paper with water. If the paper is soaked the paint becomes difficult to manage and you risk having blotches.

3 Light veins must be kept in reserve from the start, either by painting around them, or by using a masking fluid to cover them.

4 Take care – pencil shows under light coloured paint, especially yellow. Be careful to rub out pencil lines before applying colour.

5 To avoid paint bleeding into another area, wait till the first area is dry before starting the next.

6 Make sure you have enough paint to finish the drawing. You don't want to have to mix another batch, with the risk of not getting the same shade.

7 Little specks of paint on damp paper can have a pretty effect, but are often unintended!

8 Paint does not spread very much on dry paper, so there is a risk of leaving brush marks.

9 Paint will not spread beyond the damp section. It stops at the edge of the leaf.

10-11 Always start your watercolour with the lightest colours, as it is easy to darken but more difficult to lighten. To show and emphasise body, add shadows wherever possible (see p12).

Quick observation sketches of plants

A plant grows around a main axis, generally the stem or a central vein. Once this axis has been located, and quickly drawn, it is much easier to sketch the rest of the subject. The plant should be drawn in a natural position.

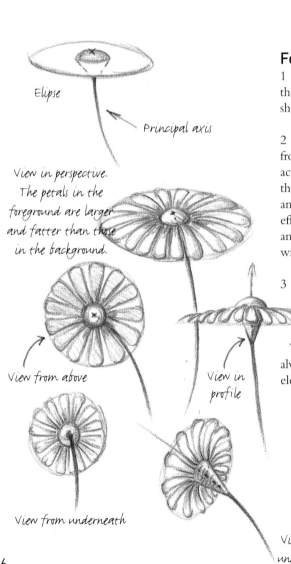

Elipse

Principal axis

View in perspective. The petals in the foreground are larger and fatter than those in the background.

View from above

View in profile

View from underneath

Foreshortening

1 First of all I look for the general shape, to get the proportions right and position it well on the sheet of paper. It is then easier to add the details.

2 With this round flower, where the stem comes from the centre, I know the shape will change according to the position. Viewed from the side, the circle becomes an elipse. To understand and visualise these foreshortening effects, look at your hand: the palm and fingers represent the flower, the wrist and arm are the axis of the stem.

3 In profile, we can no longer see the whole flower. You cannot show at the same time where the flower is attached, and its centre.

To make the drawing a coherent whole, you must always draw the axis (1) first and the surrounding elements (2 and 3) after.

View from underneath

View face on

Three-quarters view

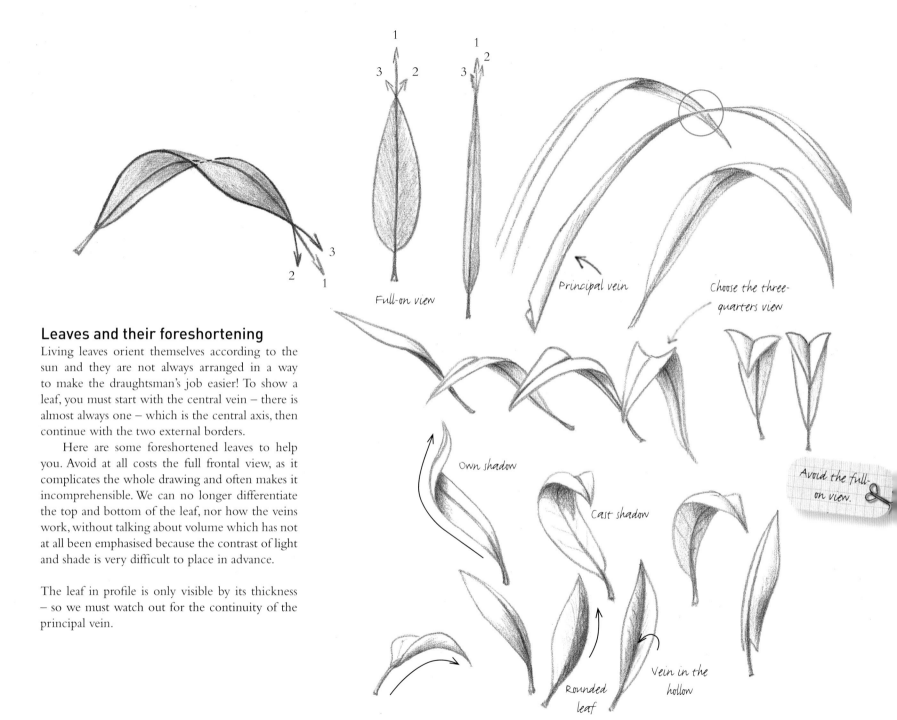

Leaves and their foreshortening

Living leaves orient themselves according to the sun and they are not always arranged in a way to make the draughtsman's job easier! To show a leaf, you must start with the central vein – there is almost always one – which is the central axis, then continue with the two external borders.

Here are some foreshortened leaves to help you. Avoid at all costs the full frontal view, as it complicates the whole drawing and often makes it incomprehensible. We can no longer differentiate the top and bottom of the leaf, nor how the veins work, without talking about volume which has not at all been emphasised because the contrast of light and shade is very difficult to place in advance.

The leaf in profile is only visible by its thickness – so we must watch out for the continuity of the principal vein.

Full-on view

Principal vein

Choose the three-quarters view

Own shadow

Cast shadow

Avoid the full-on view.

Rounded leaf

Vein in the hollow

Rapid sketches, hides and animal observation

The drawing of an animal always starts from the same base: a head, neck, trunk, and two or four legs. To this base you must add, for each animal, the important specific details which are indicators of where it lives and what it eats. Thus birds of prey are recognised by their talons and their beaks, adapted to tear meat to shreds...

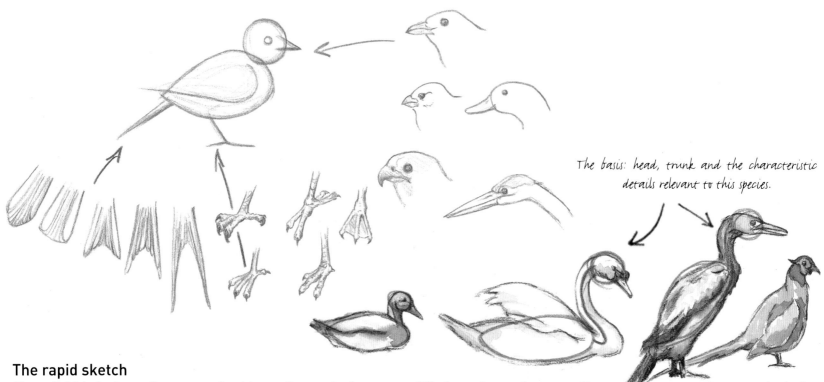

The basis: head, trunk and the characteristic details relevant to this species.

The rapid sketch

Above all, this is the time to fix on a natural position. The silhouette can be drawn with one simple line, without lifting the pencil, with only the exterior curves to show the stance. Practise making quick, minute sketches to catch a movement. Stopwatch! Not more than one minute per drawing. That will only give you time to go for the essentials.

Some animals are more difficult to observe than others. There are some, tracked during the hunting season, that are always very elusive. There are migrating birds that are not always there, there are animals that are rare and those that hibernate and only live in certain small habitats or specific geographical zones.

Zoos enable us to see close up animals that you would never be able to approach in the wild. Take advantage of this to learn how to make quick observation sketches. Animals used to the public are far from wild, and you can observe them at very close quarters.

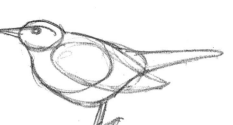

1

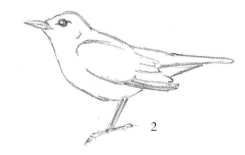

2

Sketch a blackbird

A sketch can be a summary, showing the main charateristics which enable us to recognise and identify the creature.

Here are the different stages.

1 I position the different elements and adjust the proportions.

2 Once the outlines are drawn I rub out the lines of construction.

3 Rapid pencilling to show shading adds body and substance to the subject.

4 This more finished drawing is the result of previous observations. The shading and the details give life to the bird. The shade cast on the ground adds realism to the drawing by positioning the bird. See also p.72 'The blackbird'.

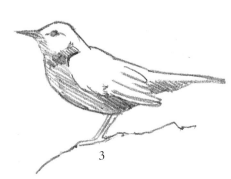

3

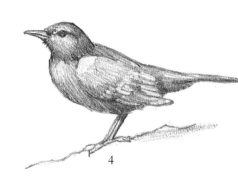

4

In a silhouette, always pay attention to drawing or sketching in the feet: they position the subject and give it life.

Taxidermists often have 'marvels' in their cupboards. This is an opportunity to see at close quarters animals you would never be able to approach or touch. But be careful: some of these animals are not shown in a natural, live pose and in that case, even if the drawing is good, the portrait of the animal will be stiff and lifeless.

The main plant textures and structures

The smoother the material, the more it shines. The more concave a surface, the more it catches the light, making a contrast between light and dark areas. In a metal engraving the ink stays in the hollows: it is the same principle for shadows, which are in the hollows or behind a volume. When the slope is gentle and rounded, the light reduces gradually towards the shade. It is the major principle when showing body or texture.

In this drawing in Indian ink, we can easily see the difference between a smooth surface, indicated by gradual shadowing, and a rough surface where the shadows are more obvious because they are in the hollows.

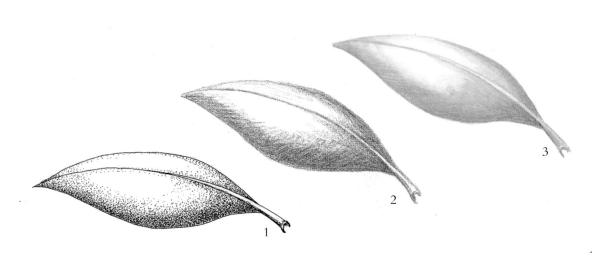

The more contrast there is between light and shade, the more the shadows are marked.

Three techniques

These identical leaves are drawn using three different techniques which bring out the play of light, thanks to the white paper being left in reserve.

1 Technique of applying ink point by point. The shiny area stays white, i.e. the colour of the paper, and the shadow is shown by the points. The darker the area, the closer and denser the dots of ink.

2 Rapid pencilling must be done in the direction of the slope to accentuate the visual effect of the sloping.

3 The transparency of watercolours allows progressive gradations in colour. The light zone is the one with least paint. The more pigment I put on, the darker the colour.

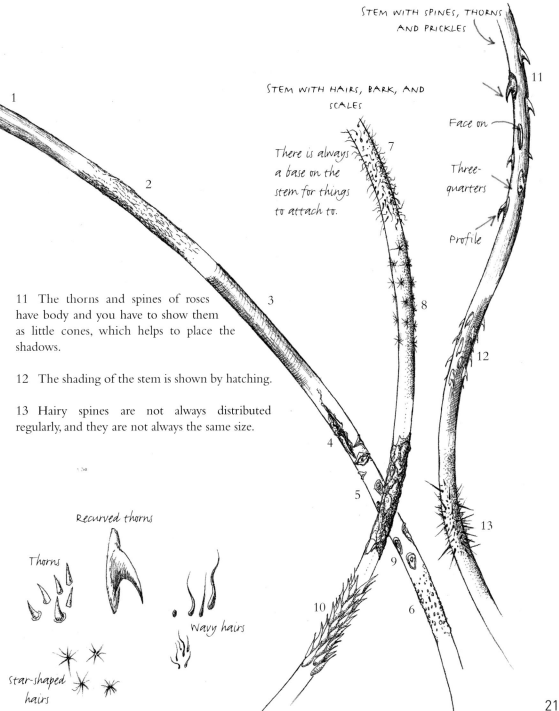

Textures

A plant stem is rarely smooth from one end to the other. It is a cylinder, very often adorned with a multitude of hairs, lumps, thorns, scales, scars, veins… So you must look at it closely before drawing.

1 The smooth appearance of the light area will be less precise, shown by lines that follow the shape of the stem and the regular line of the shine in the centre.

2 Slightly textured, this stem is lumpy at the edges.

3 Smooth, but the lines that depict it are rounded for the thickness of the stem.

4-6 The hollows of scars are darker and, if they are raised, a little shadow at the other side of the light will give them body.

7 Wavy hairs are shown by light strokes, thick and thin.

8 All the hairs emerge from the same spot for the star-shaped pubescence.

9 Bark and its raised surface are shown in the same way as the scars.

10 Scales come in many shapes. As they cover the stem, some are shown face on, while others are shown three-quarters or in profile. It is the placing of the shadow on each scale that gives body to the whole.

11 The thorns and spines of roses have body and you have to show them as little cones, which helps to place the shadows.

12 The shading of the stem is shown by hatching.

13 Hairy spines are not always distributed regularly, and they are not always the same size.

SMOOTH STEM, WITHOUT SKIN OR SCALES

STEM WITH SPINES, THORNS AND PRICKLES

STEM WITH HAIRS, BARK, AND SCALES

There is always a base on the stem for things to attach to.

Face on

Three-quarters

Profile

Recurved thorns

Thorns

Wavy hairs

star-shaped hairs

Animal textures: scales

Scales are rigid plaques that protect the bodies of reptiles, fish and certain insects such as butterflies. They are different according to where the animal lives. Often smooth on tree snakes but more streamlined on aquatic species, scales permit them to slither, and with each undulation to cling to the rough patches on the soil.

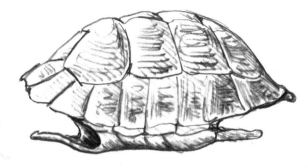

Snakes

The back scales are for protection. Small and oblong, they are held together by a skin which allows them to spread out when the snake swallows a large prey. The scales underneath are also overlapping. They cover the whole abdomen all along the length of the snake.

Tortoises

Much harder than the scales of snakes or lizards, the tortoise scales are not overlapping, but placed side by side, forming a carapace that covers the animal's skeleton.

Less rapid than the snake, the tortoise curls up in its shell to escape danger and protect itself. The neck and attachments for the legs and tail to the body are covered with skin, while the legs, head and tail have scales like those of the lizard. The scales have different shapes according to where the tortoise comes from. If you make detailed studies, note all the details of these scales, for the number of ridges gives information about the age of the tortoise. The colours and shapes are so specific that they also indicate the variety. To draw a structure made of scales, you have to count them!

Detail of the shell of the Hermann tortoise.

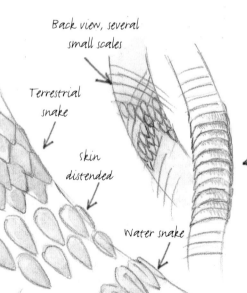

Back view, several small scales

Terrestrial snake

skin distended

Water snake

Tree snake

View of the stomach. Each scale is as wide as the abdomen.

The skin on snakes is taut. The scales move apart to allow a large prey to pass through, or when the snake is alarmed.

On the shell, you can easily see the growth marks and the direction of growth of each scale over the seasons.

From butterflies to lizards

The scales are often different on the same individual, varying according to how they are used.

On the lizard, for example, the scales on the top of the tail are more ridged (more raised) as tails are used in combat between males or to defend themselves against predators.

The wings of a butterfly are covered with powdery scales which, close up, resemble a roof covered with flat tiles.

The arrangement of scales is very structured. Each one has a colour and it is the ensemble of these scales that forms a design in magnificent colours. For all these reasons it is the technique of applying paint point by point that will enable you to achieve the most faithful rendering.

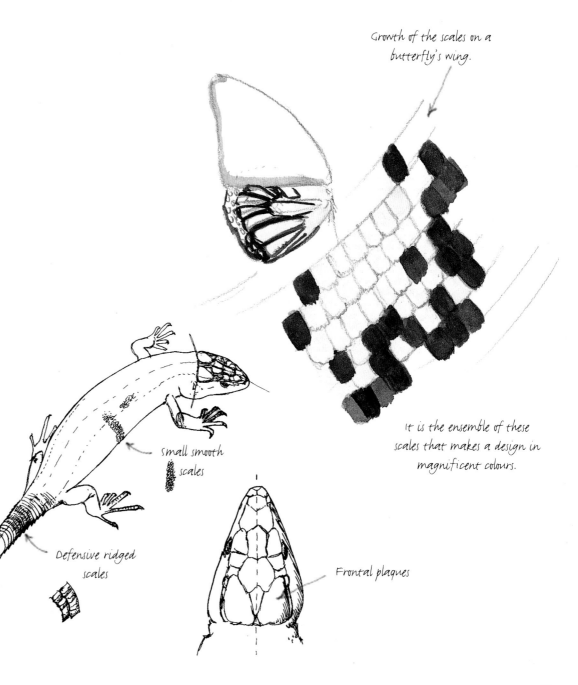

Growth of the scales on a butterfly's wing.

It is the ensemble of these scales that makes a design in magnificent colours.

Projecting ridge

small smooth scales

Defensive ridged scales

Frontal plaques

23

Skin and hair

I recommend you to try these details: a fox's tail or a feather because, to succeed with these delicate textures, it is more necessary than ever to learn how to handle paint, pencil and water. Once you have mastered the technique, you will find it easy to apply it to the whole drawing.

Showing skin

A colour wash enables you to show skin, but more often there are contours, hollows and bumps that can be brought out with another brushstroke of the same pigment. That is the case with the green frog (see p.36).

A second brushstroke with the same colour.

Skin is rarely uniform. Often there is a grain, or marks. To give body, and show the lumps on the toad, for example (see p60) it is enough to outline certain areas; the more they are outlined, the more body they will have.

Hair usually always lies in the same direction.

Watercolour pencils are perfect for drawing hair with a natural movement. Afterwards, applying a little water unifies the whole, while keeping the details and the fluffy effect.

Rapid pencilling with watercolour pencils can give an attractive texture once it has been moistened.

Showing hair

The downy effect of a winter fur can be obtained by letting the paint work alone. You must dampen the paper and then add water and paint in little strokes, more or less spaced, according to the desired effect. It is the technique called wet on wet.

1 Paint scarcely diluted, applied to dry paper, will have the opposite effect: the paint does not merge (so every stroke counts!).

2 To show a thick fur, the light hairs must be painted first. Then, on top, with less water and a dry brush, the other, darker hairs, hair by hair. Spaced out hairs give the impression of a fur with lighter areas.

3 Several colours can be used to thicken the fur. With watercolours, you must start with the lightest, the opposite to gouache.

4 The effect is different according to the direction of the strokes for the hair. Stippling, strokes with a stiff or a fine brush will have a very varied effect.

5 Small touches which follow each other give an effect of sheep's wool, and curved strokes can indicate the haunch under the coat. The base colour is important: if it is too dark, it lowers the depth of the coat.

6 Dry brush with only a little paint on dry paper.

7 Movements in the hair give depth, or show a change of colour.

8 Long hairs are drawn in the same way as short, but they must be drawn in a single movement, without lifting the brush, so as not to have to go over the stroke again.

On damp paper I apply the colour with little touches of the brush. The water will do its work in diffusing the pigment.

The results will be different if the touches are closer together and the pigment is thicker.

On insects, hairs are silky. They work in the same way, according to their density.

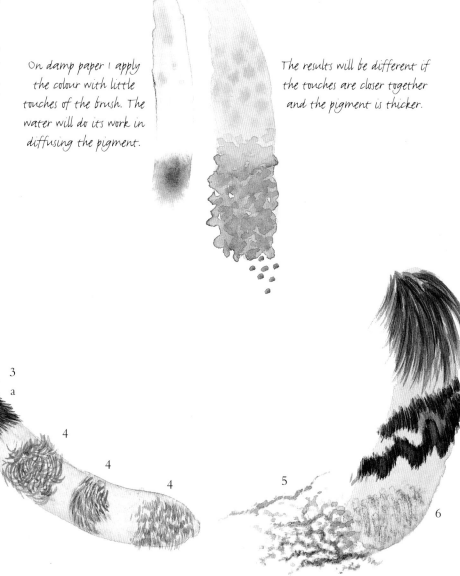

25

Feathers

Plumage is of major importance for a bird. It enables it to fly, protects it from the weather and acts as a camouflage against predators. Moreover it plays an important role in mating displays.

To gain time, or make sure of the proportions of a feather, it is enough to place the feather on the paper, hold it there with a finger and then delicately, not pressing down too much, draw round the outline with a pencil.

Play with realism

It is the plumage that will give life to your bird drawings. Know how to play on that realism, showing the arrangement of feathers in relation to each other and highlighting their natural positions. A little sparrow puffs up its feathers in cold weather, a great crested grebe shows off its attractions with feathers erect. Even if they seem light, and at first glance translucent, some feathers don't allow light through. Laid down, they cast a shadow. The addition of this shadow allows us to place the feather in space, to give it body and more presence on the page.

The arrangement of feathers is fundamental and must be respected. It must be visible in the drawing. In the same species there are natural variations in colour, and sometimes in shape according to the individual. All wild ducks look alike, but they are not totally identical. These natural little variations will make your drawing more life-like.

Get into the habit of collecting feathers when out walking. Identify them, and keep them for your next drawing.

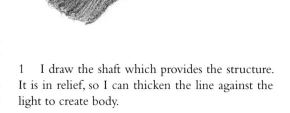

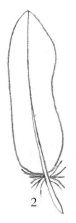

1 2 3

1 I draw the shaft which provides the structure. It is in relief, so I can thicken the line against the light to create body.

2 To define the general shape of the feather, I draw a quick line, light enough not to box it in. If this line is too marked, I blur it with a rubber.

3 To draw the barbs (filaments), I place the pencil or brush inside the feather, alongside the rib, then I bring it to the outside, bringing the point to the edge of the feather. In this way each barb will be well defined, the base attached to the shaft, and the point will be fined by raising the pencil or the point of the brush.

You can also be happy just with a sketch.

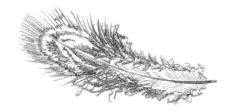

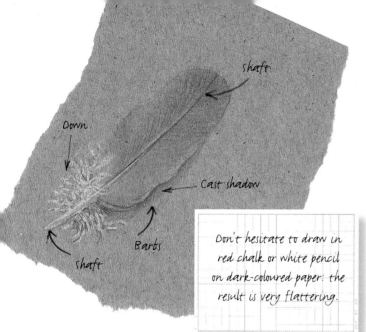

shaft

Down

shaft

Cast shadow

Barbs

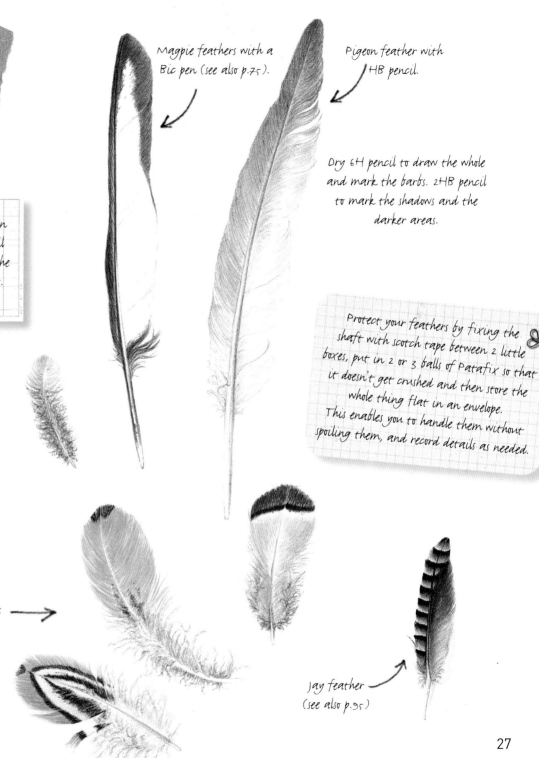

Magpie feathers with a Bic pen (see also p.75).

Pigeon feather with HB pencil.

Dry 6H pencil to draw the whole and mark the barbs. 2HB pencil to mark the shadows and the darker areas.

Don't hesitate to draw in red chalk or white pencil on dark-coloured paper: the result is very flattering.

Protect your feathers by fixing the shaft with scotch tape between 2 little boxes, put in 2 or 3 balls of Patafix so that it doesn't get crushed and then store the whole thing flat in an envelope. This enables you to handle them without spoiling them, and record details as needed.

Each feather has its function

The body of a bird is covered with little feathers which form a quilt, apparently quite disorganised. This is then covered with more robust, structured feathers, the coverts.

The wing and tail feathers are the longest, called the flight feathers. To be precise, the wing feathers are called the remiges and the tail feathers are called the rectrices. With a shaft that is both straight and supple they allow the bird to fly and to change direction. This aspect can be seen in the illustration.

Pheasant feathers. A mixture of watercolours and dry pencil enables us to show more easily the lightness of the little feathers and the down. These three feathers belong to the same bird (see also p.77).

Jay feather (see also p.95)

27

Reflections: dewdrop, refraction in the water

A drop of water can give life and freshness to a drawing. To make the brightness and transparency of the water stand out, it is important to use the supporting surface to show the volume of the drop, through to the contrast of light and shade.

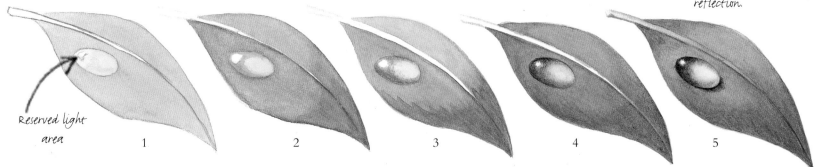

Perylene green which contrasts with the light reflection.

Reserved light area

1 2 3 4 5

How to draw a drop of water

In this example, the basic support is a leaf, but the principle is the same for a stone, petal or anything else. However, be careful to be true to nature: on a horizontal branch there is a large chance that the drop would fall underneath!

1 I draw the leaf which will be the support, then I place the drop and give it shape. From the start, I keep the reflection of the light to the interior of the drop, putting masking fluid on this area. As the fluid is thick, I apply it with a small pointed stick, or with a brush with a fine, stiff point. When the masking fluid is dry, I apply a light yellow wash all around and on the inside of the drop to illuminate it and give it brilliance.

Inside and on the edges I add a green wash on the still damp paper. The water will naturally diffuse the green with the yellow. The left side of the drop, the side of the light, will be the darker side.

2 Knowing that the darkest area of the drop is on the side of the light, the light side will be on the opposite side, and it is this contrast that is going to give the form its rounded shape.

3 Once the paper is dry I rub to remove the masking liquid and the remaining lines of the drawing.

4 I darken again around the shiny area, making small touches with a fine brush and very little water in order to keep control over the paint. I add chromium green oxide.

5 I darken with little touches of perylene green to accentuate the contrast with the reflected light which is going to seem even whiter. To add body to the drop and show how it is poised, I draw a cast shadow on the leaf, on the side opposite the reflection. I colour the shadow either with Payne's grey or perylene green. I gradually darken the leaf.

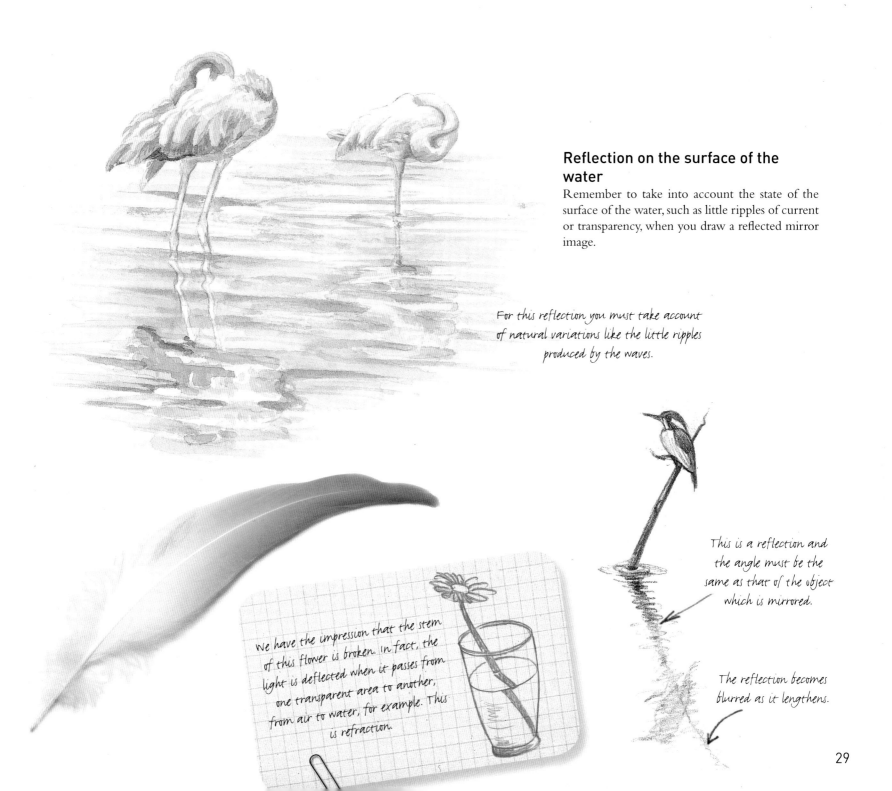

Reflection on the surface of the water

Remember to take into account the state of the surface of the water, such as little ripples of current or transparency, when you draw a reflected mirror image.

For this reflection you must take account of natural variations like the little ripples produced by the waves.

We have the impression that the stem of this flower is broken. In fact, the light is deflected when it passes from one transparent area to another, from air to water, for example. This is refraction.

This is a reflection and the angle must be the same as that of the object which is mirrored.

The reflection becomes blurred as it lengthens.

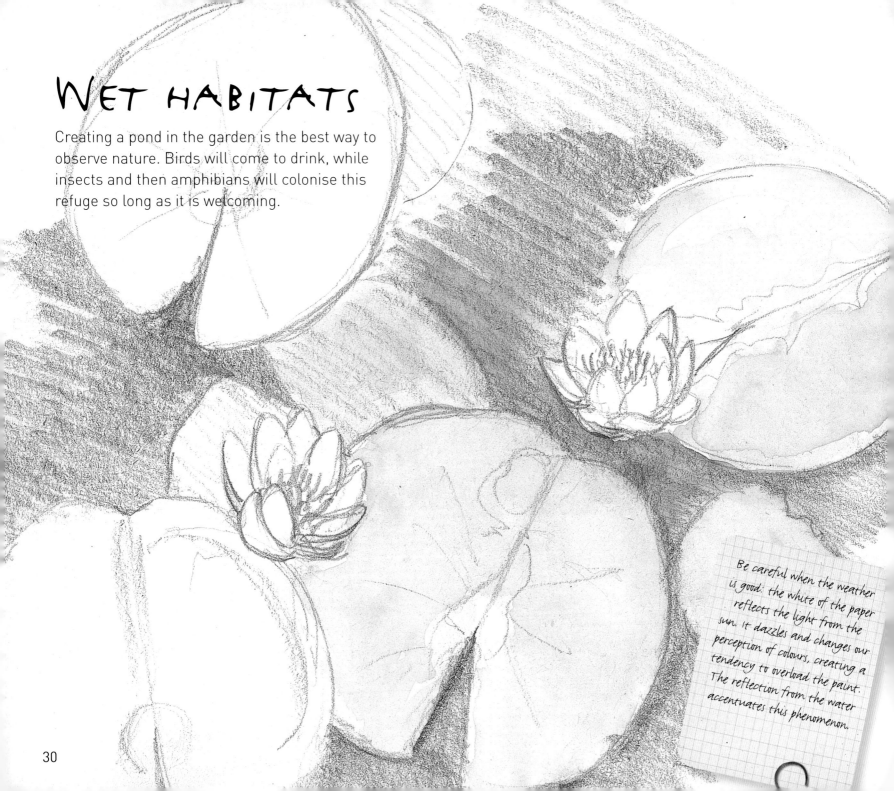

Wet habitats

Creating a pond in the garden is the best way to observe nature. Birds will come to drink, while insects and then amphibians will colonise this refuge so long as it is welcoming.

Be careful when the weather is good: the white of the paper reflects the light from the sun. It dazzles and changes our perception of colours, creating a tendency to overload the paint. The reflection from the water accentuates this phenomenon.

How do you draw a white water-lily?

The white water-lily, *Nymphaea alba*, flowers from June to September. In winter it seems to disappear, but in fact it is hibernating in the silt, protected from the cold. This plant consists of a rhizome – the underground stem and food reserve that enables it to pass the winter submerged – roots, stems, leaves and flowers that float on the surface of the water. Even when cut and put in a vase, the flower of the water-lily continues to open in the morning and close in the late afternoon. Although it lasts almost a week, giving the draughtsman time to put the finishing touches to his drawing, it does not do well too long out of the water. If you want to draw a water-lily you must organise to work in the summer months, and pick the flower or draw it *in situ* early in the morning.

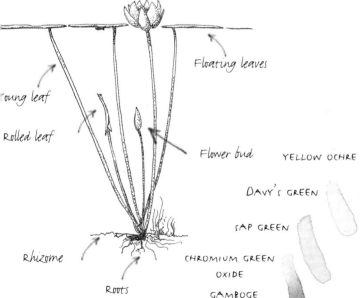

Floating leaves

Young leaf

Rolled leaf

Flower bud

Rhizome

Roots

YELLOW OCHRE

DAVY'S GREEN

SAP GREEN

CHROMIUM GREEN OXIDE

GAMBOGE

OLIVE GREEN

Closed, the flower has a cone shape; open, it is bowl-shaped.

For the shadow, I do tests to find a good colour, neither too light nor too dark.

The white of the petals is enhanced by the contrast with the green of the sepals and the dark colour of the water.

The more the flower bends towards the sun, the larger the shadow cast on the stem.

Mixture of Davy's grey and sap green for the shade inside the petal. The sap green, a little acid, makes the Davy's green less heavy, less lifeless, less muddy. This mixture enables you to retain the freshness of the white.

31

The marsh iris

Iris pseudacorus is a species that grows in water, producing graceful bright yellow flowers that contrast with the green foliage. This plant can grow up to a metre high, and its foliage is semi-hardy in winter. The upright flower stem is stiff and slightly flattened. Once cut, the flower does not last long: only a few hours if the weather is hot. If the location is suitable, it is better to draw this flower *in situ*.

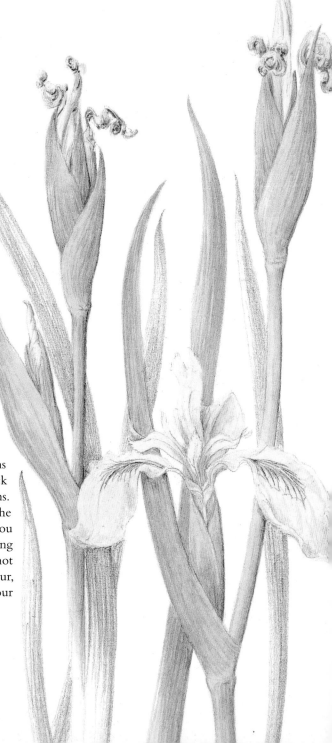

> **DID YOU KNOW?**
>
> Clovis, King of France made it his emblem, and King Louis VII also adopted it after him. It ended up becoming the emblem of the Kings of France under the name 'Fleur de Loïs'. In time, with the help of writing, it became 'La fleur de lis', the historic fleur-de-lys.

Withered flowers

Drawing flowers that are beginning to wilt, or already withered, enables you to make a realistic drawing, as it will carry supplementary information about the plant. Do these flowers all appear at the same time, or is there a sequential order to the flowering?

Often the colours of dried-up plants are quite pretty, in shades from ochre and orange to sepia. The flower must be treated as a cone, whether it is open or in bud.

With this variety I often note variations in colour on the tepals, and especially black spots in a semi-circle situated on the veins. Opposite, the pencil comes through under the watercolour, an artistic choice that allows you to give body, or a different texture. Not having paint at hand is by no means an excuse for not doing a drawing. Take notes about the colour, and photos to remind you. Putting in colour can be done later if necessary.

Yellow is one of the two colours, along with white, that quickly looks muddy. Always use a clean brush and clean water to keep a clear yellow.

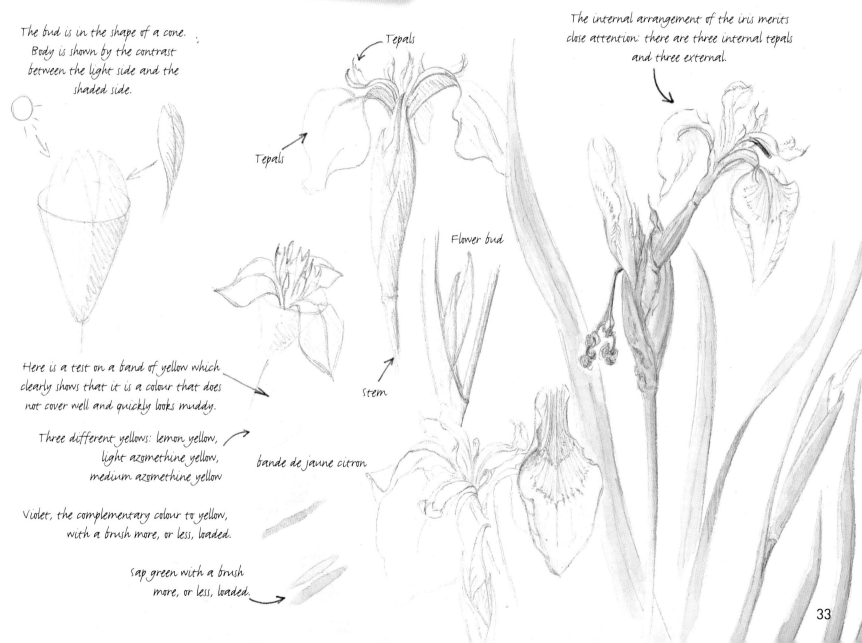

The bud is in the shape of a cone. Body is shown by the contrast between the light side and the shaded side.

The internal arrangement of the iris merits close attention: there are three internal tepals and three external.

Tepals

Tepals

Flower bud

Stem

Here is a test on a band of yellow which clearly shows that it is a colour that does not cover well and quickly looks muddy.

Three different yellows: lemon yellow, light azomethine yellow, medium azomethine yellow

bande de jaune citron

Violet, the complementary colour to yellow, with a brush more, or less, loaded.

Sap green with a brush more, or less, loaded.

Dragonflies

Everyone knows about dragonflies, these superb insects that inspired the inventor of the helicopter!
In order not to confuse them with damselflies, look at them at rest.

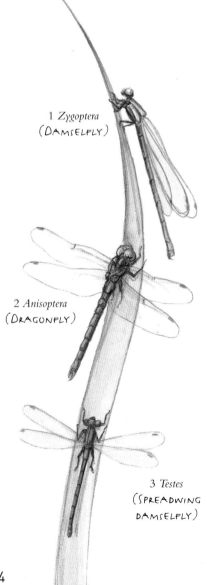

1 *Zygoptera*
(DAMSELFLY)

2 *Anisoptera*
(DRAGONFLY)

3 *Testes*
(SPREADWING
DAMSELFLY)

Damselfly or dragonfly?

Scientifically, both belong to the order odonata. Damselflies (zygoptera) are easily identified by their wings, which are folded back along the body (or on top of it) when at rest. True dragonflies (anisoptera) keep their wings open horizontally when at rest. When observing them, it is important to know how to tell the difference, so that the drawing is accurate, and is on no account a mixture of the two.

Odonata are easily recognised by the slender body, large globular compound eyes and two pairs of wings. Like other insects the body has three segments: head, thorax and abdomen.
The head has the eyes and short antennae, scarcely visible.
The thorax has three parts, with three pairs of legs and two pairs of wings.
The abdomen has ten visible segments.

The eggs are laid in stagnant or slow-running water and this is where the larvae develop. When they emerge from the water the adult insect moves with difficulty, so it is then easy to approach close enough to draw. But after this stage it is not worth hurrying, because they can fly at more than 25mph! So you must wait for the dragonfly to settle to observe and sketch it on paper.

The insect is painted in watercolours, but the wings are drawn with a 0.25mm pen. Be careful: you must paint the background first and then wait till the paper is quite dry before drawing the wings. They can be done with a Bic pen, pencil or paint, or a mixture of these techniques. The young insects, males and females are all different colours.

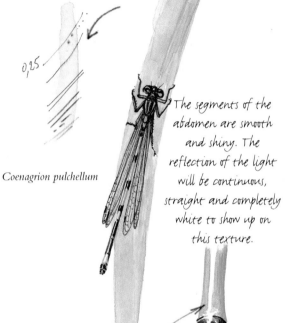

0,25

Coenagrion pulchellum

The segments of the abdomen are smooth and shiny. The reflection of the light will be continuous, straight and completely white to show up on this texture.

Enlarged sections of the abdomen: the white is done in gouache on top of the base colour. Personally, I prefer the technique which uses the white of the paper.

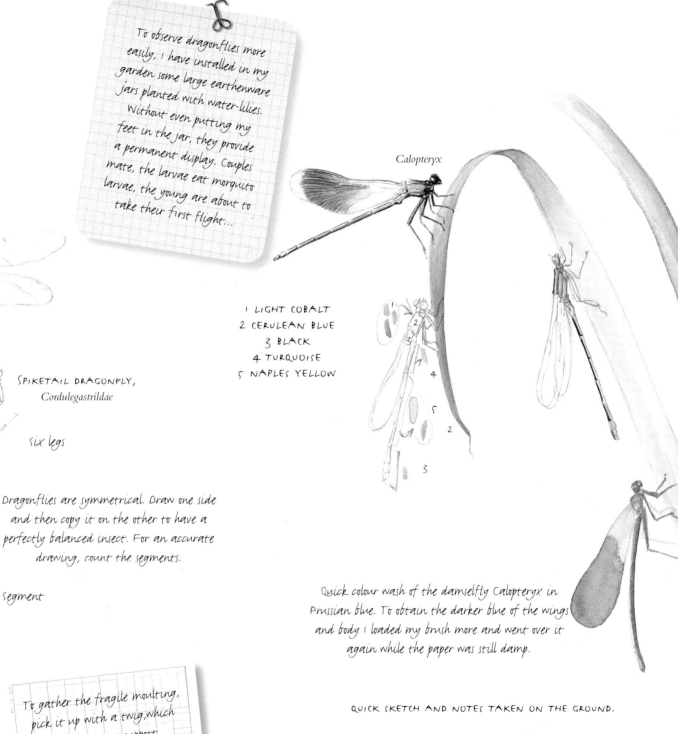

SKIMMER DRAGONFLY
Libellulidae

To observe dragonflies more easily, I have installed in my garden some large earthenware jars planted with water-lilies. Without even putting my feet in the jar, they provide a permanent display. Couples mate, the larvae eat mosquito larvae, the young are about to take their first flight...

Calopteryx

1 LIGHT COBALT
2 CERULEAN BLUE
3 BLACK
4 TURQUOISE
5 NAPLES YELLOW

SPIKETAIL DRAGONFLY,
Cordulegastrildae

six legs

Dragonflies are symmetrical. Draw one side and then copy it on the other to have a perfectly balanced insect. For an accurate drawing, count the segments.

segment

Begin with the light colours, such as yellow. Once it is dry the black can hide any errors, but not the other way round.

To gather the fragile moulting, pick it up with a twig, which will serve as a support

Quick colour wash of the damselfly Calopteryx in Prussian blue. To obtain the darker blue of the wings and body I loaded my brush more and went over it again while the paper was still damp.

QUICK SKETCH AND NOTES TAKEN ON THE GROUND.

35

The green frog

This frog, which measures about 10cm, is very common in Europe. It lives in lakes, marshes, ponds and slow-running streams. In winter, it hides in the mud and waits for the good weather. It mainly eats insects.

Tireless singer

It very easily finds its bearings between March and April, the mating period, with hundreds of fellow creatures. On the other hand when it is silent it is very difficult to spot, for its colour and markings make the perfect camouflage. The main colour is green, but it can also be brownish, with lots of dark brown spots, and I have even seen a bluish one. The underside is whitish with grey spots. Finally, the pupil of the eye is horizontal and the back feet are webbed.

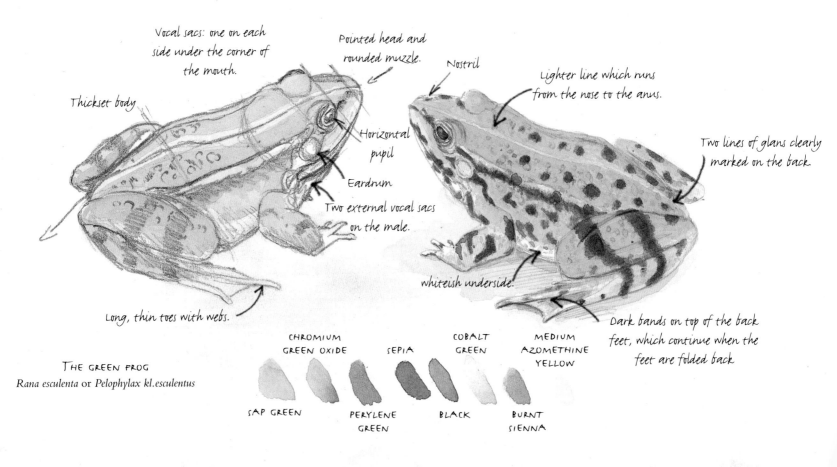

Vocal sacs: one on each side under the corner of the mouth.

Pointed head and rounded muzzle.

Nostril

Lighter line which runs from the nose to the anus.

Thickset body

Horizontal pupil

Eardrum

Two external vocal sacs on the male.

Two lines of glans clearly marked on the back.

whiteish underside.

Long, thin toes with webs.

Dark bands on top of the back feet, which continue when the feet are folded back

THE GREEN FROG
Rana esculenta or *Pelophylax kl.esculentus*

CHROMIUM GREEN OXIDE

SEPIA

COBALT GREEN

MEDIUM AZOMETHINE YELLOW

SAP GREEN

PERYLENE GREEN

BLACK

BURNT SIENNA

The tree frog

This is found in marshes, and in woods near water, in central and southern Europe. It is one of the rare frogs and is mainly active at night. By day it rests under leaves and along branches with its feet drawn in, and so passes unnoticed.

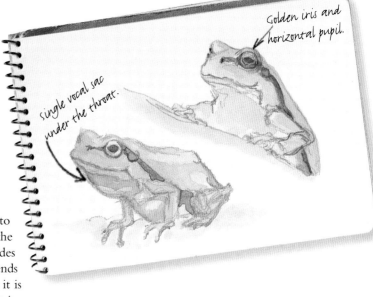

Golden iris and horizontal pupil.

single vocal sac under the throat.

A night creature

It also comes out during the day to bask in the sun, stretched out along the stems of aquatic plants. In winter it hides in cracks or holes. In spring, it spends its time near water. To see it at night it is enough to have a head-lamp, so that its eyes are reflected in the light. So if you see someone taking a night-time walk in the mud, it's me, or a reader of this book! It is a very good technique for seeing animals you would not otherwise see. It works equally well with alligators and crocodiles, or boa constrictors, but that's another story…

A luminous green

Hyla arborea is a little frog measuring 5cm. Its smooth skin is bright green, but there are variations that are yellowish, olive or even grey. A lateral stripe, sepia-coloured, runs from the nostril, across the eye to the sides and down to the top of the back feet. There is a small lighter area, white or yellowish, between the green and the brown band. The stomach is greyish-white.

Like a lot of amphibians the damp skin secretes a mucus which is toxic to predators, so be careful not to touch your eyes after handling one.

After drawing it, I apply golden green over the whole frog, except for the eyes and the underside. When the paper is dry I go over it again with sap green. Superimposing these two colours gives a luminous green.

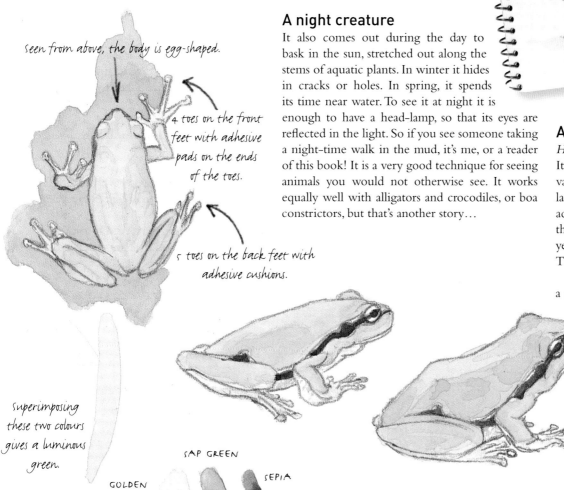

seen from above, the body is egg-shaped.

4 toes on the front feet with adhesive pads on the ends of the toes.

5 toes on the back feet with adhesive cushions.

superimposing these two colours gives a luminous green.

GOLDEN YELLOW

SAP GREEN

SEPIA

The yellow and black salamander

This is easily recognised by its colour: shiny black with reddish or egg-yellow patches. The large flat head, rounded jaw, large mouth and two eyes are completely black. Unworried, it seems to say, 'Make sure you don't eat me. Look at my colour, I'm toxic.' And in fact it secretes a venom through its pores (avoid touching your eyes if you handle one).

A little marvel

Wherever it is, avoid touching it so as not to damage or poison it, as its fine damp skin is very fragile. Wet habitats are becoming rare in Europe, so its numbers are in decline, like all amphibians.

Salamanders mate on the ground and give birth in water to young already formed, but still with gills. There they finish their development before taking refuge in the woods under leaves and stones from which they emerge at twilight, at night or after rain to hunt for slugs and worms. You will find them more easily in the evening, after a gentle rain; never in the winter or in full sun.

How to draw a salamander

1 After sketching the general shape, I roughly draw the body and head.

2 I add some details, such as the position of the eyes, some patches and the correct number of toes. I reserve the lighter areas, such as the top of the back and the rounded areas.

3 I apply all the yellow patches and lastly the black.

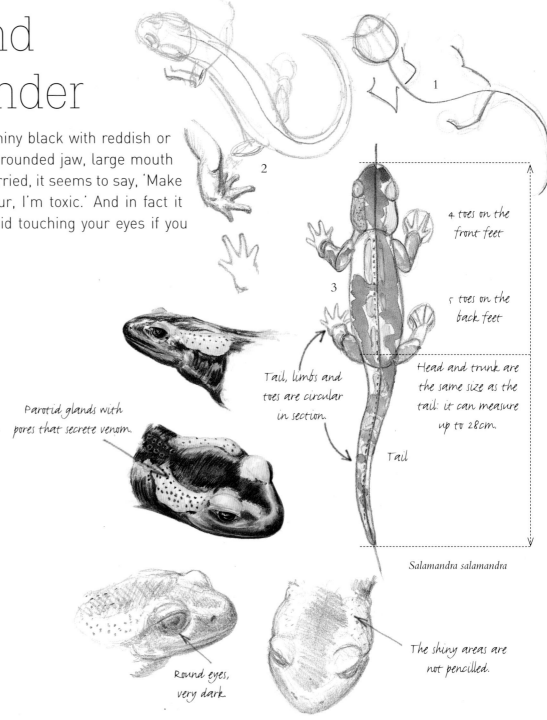

1

2

3

4 toes on the front feet

5 toes on the back feet

Head and trunk are the same size as the tail: it can measure up to 28cm.

Tail, limbs and toes are circular in section.

Tail

Parotid glands with pores that secrete venom.

Salamandra salamandra

Round eyes, very dark.

The shiny areas are not pencilled.

The newt

It is interesting to compare the salamander, which is quite large and bulky, with the newt, which is smaller and lighter. Newts, like salamanders, are land animals, but go into the water at mating time. Generally speaking, this is the moment when they are most visible. On the other hand, once they have laid their eggs they roll them in leaves.

The head of the Alpine newt is a real jewel: the top is cobalt blue, the underside orange and, in between, it is embellished with a white band speckled with black. I start by putting on yellow.

The female of the common newt, *Triturus vulgaris*, is a basic light brown colour, with sepia spots on the back, sides, stomach and throat. The crest, which begins at the level of the back, is larger on the male than the female.

I apply a general ochre wash and then, when the paper is dry, I add the brown spots with sepia. A brown band starts at the nose, crosses the eyes and goes down the middle of each side, all along the body.

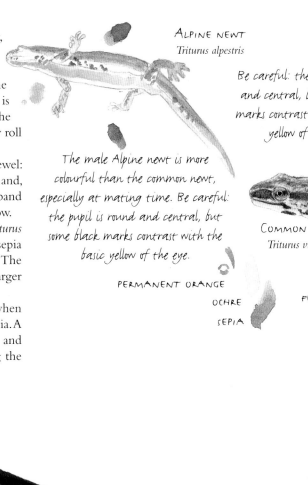

ALPINE NEWT
Triturus alpestris

Be careful: the pupil is round and central, but some black marks contrast with the basic yellow of the eye.

The male Alpine newt is more colourful than the common newt, especially at mating time. Be careful: the pupil is round and central, but some black marks contrast with the basic yellow of the eye.

PERMANENT ORANGE

OCHRE

SEPIA

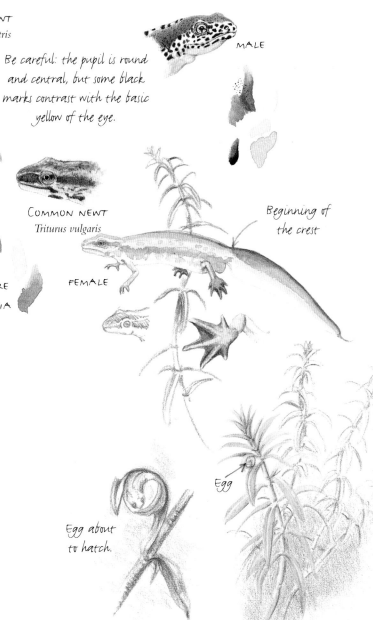

MALE

COMMON NEWT
Triturus vulgaris

FEMALE

Beginning of the crest

Egg

Egg about to hatch.

The brilliant reflections on the smooth, damp skin are rendered by the contrast between black and white, without a transition of grey-black.

The more you want to show a damp effect, the more the contrast between black and white must be stark, with no transition. If it is less damp, as in the drawings of the head on p.38, a grey tone can make the transition.

The grass snake

This handsome aquatic snake is recognisable by its yellowish white 'collar'. The adult *Natrix natrix* measures 90cm – 1.5m for the females, while the males are smaller. The grass snake lives near watery locations, ponds, lakes, streams, where it finds its prey such as frogs and fish.

Good observation prepares for the task of drawing

From the beginning of winter to the beginning of spring, the snake hibernates. It hides at the slightest movement, but it is less lively after sunbathing early in the morning. The grass snake is undoubtedly one of my favourite snakes. I find it very graphic, and above all likeable. Even when captured, it doesn't bite. It prefers to sham dead, mouth open, totally limp, tongue hanging out; but be warned: it doesn't hesitate to expel nauseating stools whose smell is very persistent on hands and clothes.

The back is grey shading into olive green, with dark patches. The stomach is lighter, with vertical black bands. Young snakes have more vibrant colours and are well marked. As with all snakes, the eye and pupil are round and there is no eyelid. The scales on the head are quite large, especially in comparison with those of French vipers.

Using a 2B pencil I start by drawing the scales on the head, which are very visible. I then apply a wash of sepia mixed with olive green over the whole snake, except the stomach. The collar is yellowish, as is the underside of the head and the eyes. Finally, I add the black to the collar, the head scales and the body markings.

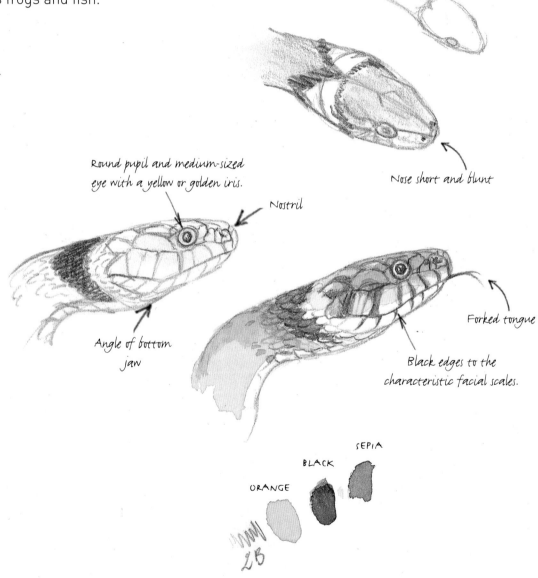

Round pupil and medium-sized eye with a yellow or golden iris.

Nostril

Nose short and blunt

Angle of bottom jaw

Forked tongue

Black edges to the characteristic facial scales.

ORANGE BLACK SEPIA

2B

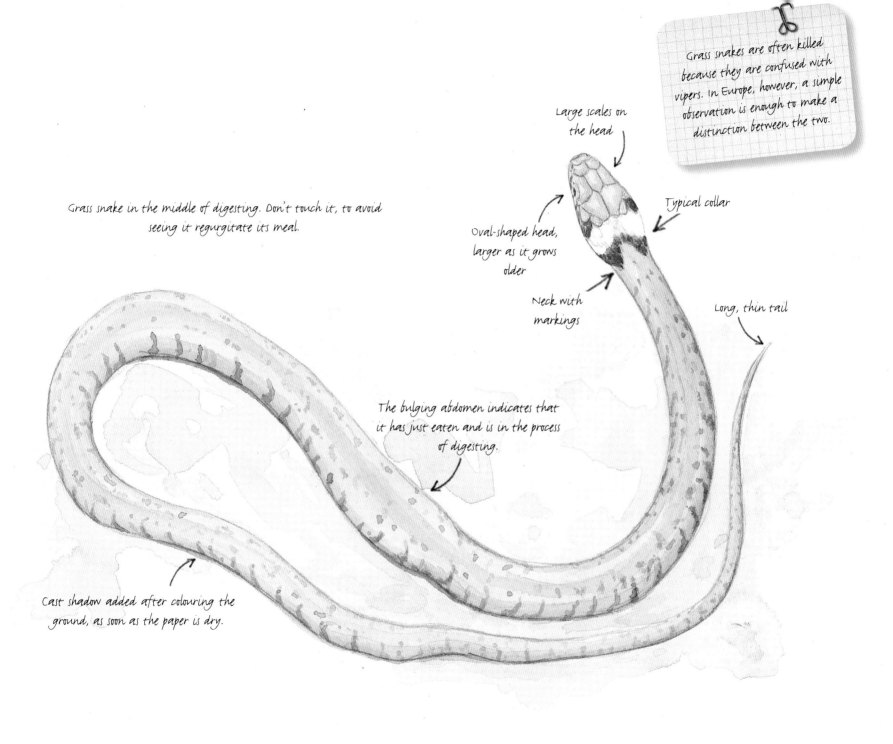

Grass snakes are often killed because they are confused with vipers. In Europe, however, a simple observation is enough to make a distinction between the two.

Large scales on the head

Typical collar

Grass snake in the middle of digesting. Don't touch it, to avoid seeing it regurgitate its meal.

Oval-shaped head, larger as it grows older

Neck with markings

Long, thin tail

The bulging abdomen indicates that it has just eaten and is in the process of digesting.

Cast shadow added after colouring the ground, as soon as the paper is dry.

41

The European terrapin

This handsome aquatic tortoise, once found over half the land mass, is now in decline all over Europe. In France, it is no longer found in some regions, and its population is much reduced because damp, boggy areas are disappearing little by little. It can be found in lakes, ponds and gravel pits, and in slow-moving rivers and streams.

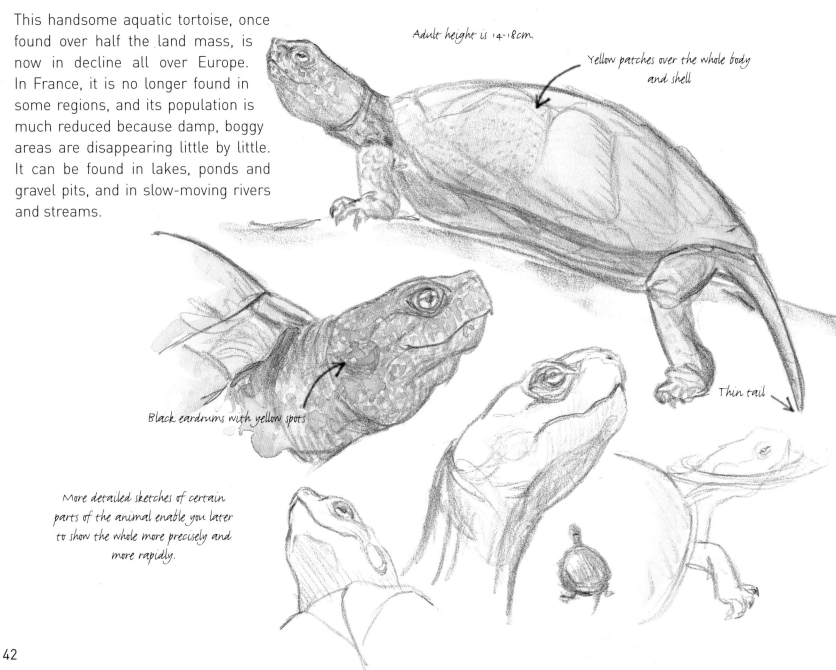

Adult height is 14-18cm.

Yellow patches over the whole body and shell

Black eardrums with yellow spots

Thin tail

More detailed sketches of certain parts of the animal enable you later to show the whole more precisely and more rapidly.

Where do you find it?

Don't look for *Emys orbicularis* when it is cold, as it stays in hibernation under the mud. In springtime, during the mating season, it warms itself in the sun and is more easily spotted. The eggs laid in June hatch out in the autumn. Like many aquatic tortoises it is a carnivore, eating frogs and toads, insects and young fish. It is in competition with the invasive 'Florida tortoise' which is very aggressive and manages to reproduce faster, and in greater numbers.

The spotting

To achieve the yellowish spotting on the black, you first have to apply the yellow and then, when the paper is quite dry, circle the yellow with black paint. Take advantage of the water around the spots to diffuse the black more and more heavily. On the neck and around the mouth the spots are not so rounded. Sometimes the yellow markings are not visible because they are covered with mud or algae.

The head is black, marked with yellow spots.

The eyes are pale golden yellow, with a round black pupil and a bronze horizontal bar most of the time.

The mouth is curved up.

The feet are strongly webbed, 5 toes on the front feet and 4 on the back feet, with pointed claws for tearing up meat.

Large thick scales on top of the feet.

POND SLIDER
Trachemys scripta

The back is slightly curved, rather dark, in tones of blue-black with a little sepia, and spots more or less yellow according to the individual.

Young tortoise measuring 3cm, quite smooth with a large tail and marked with bright yellow spots.

43

The moorhen, a water bird

Very fast-moving, timid and nervous, *Gallinula chloropus* colonises all mild or brackish water sources where there is enough vegetation to hide it. There, it quietly incubates its eggs after successive layings between April and July. It is in this environment, quiet and marshy, that it finds its food – aquatic plants, insects and small creatures.

A featherweight

It measures up to 35cm and its weight is never more than 400 grams. It finds its way about easily in the water because of its roundness, colour and jerky movements. It is completely black, with the beak slightly brownish. There is a short white band on each side and under the tail. Its red beak, yellow at the end, is welded to a facial shield. The eyes are red and the feet light green. There is no difference between males and females.

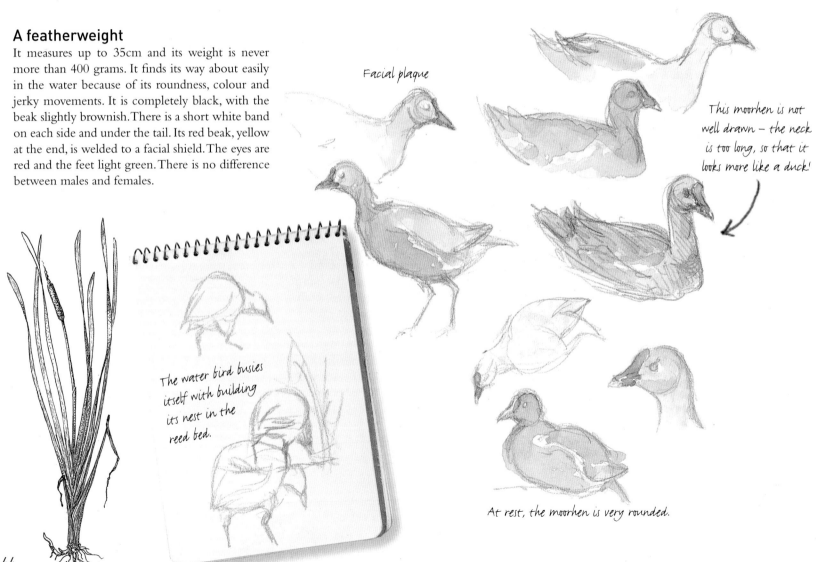

Facial plaque

This moorhen is not well drawn – the neck is too long, so that it looks more like a duck!

The water bird busies itself with building its nest in the reed bed.

At rest, the moorhen is very rounded.

Illustrate some details

I found this moorhen at the side of the road, where it had just been struck by a car. This enabled me to observe it close up, and in detail. Unfortunately the pretty water-green colour of the feet is only present when the bird is alive; afterwards it become yellow-grey.

For the observation sketches I have used sepia and black to give reflections and volume to the body. To mark certain feathers I go over them again with the brush with the same colours, a little more concentrated and as many times as necessary.

The red part of the beak is smooth and shiny. After putting on the yellow, I leave a space above for the reflection on the red beak. I put on a first coat of light permanent red: it is a little orangey. Then, on the dry paper, I apply a dark permanent red, to add shadows and body.

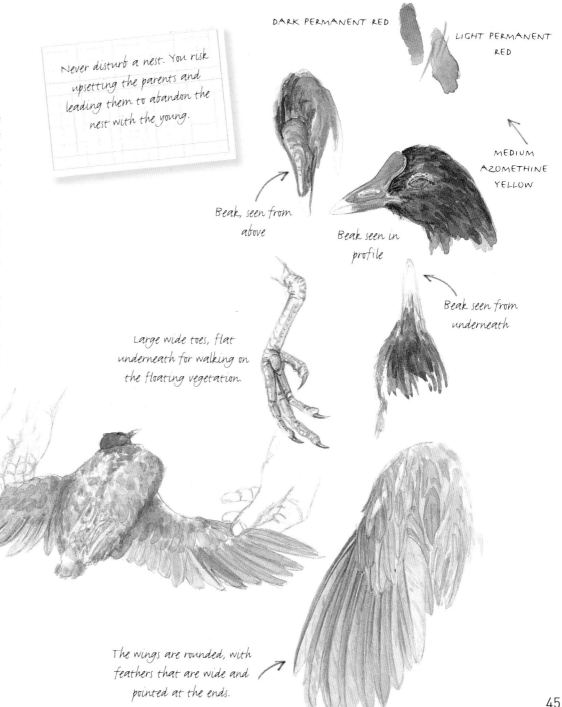

Never disturb a nest. You risk upsetting the parents and leading them to abandon the nest with the young.

DARK PERMANENT RED

LIGHT PERMANENT RED

MEDIUM AZOMETHINE YELLOW

Beak, seen from above

Beak seen in profile

Beak seen from underneath

Large wide toes, flat underneath for walking on the floating vegetation.

The wings are rounded, with feathers that are wide and pointed at the ends.

The mallard

Communal, and uninhibited during the mating season, wild ducks are easy to observe. The males fight violently and chase the chosen female persistently, not worrying about onlookers.

Not so wild!

Even though they are often hunted, the wild duck population is not about to disappear. The wild duck adapts easily, colonising public parks and gardens, even in towns, wherever there are ponds and vegetation. The female returns to her place of birth to nest, generally making the nest among the vegetation on a river bank. The young leave the nest soon after birth and follow the mother everywhere in single file from the first hours after hatching. These birds, which fly with straight, outstretched necks, also get about by rapidly beating their wings.

Iridescent wing patch

Sap green and perylene green on the head with glints of blue indigo or Payne's grey mixed with violet.

The head and neck are decorated with iridescent green feathers, with glints of blue merging into violet.

Long beak which goes from yellow to greenish with a tab at the end, black on the male and orangey with black spots on the female.

A white collar separates the neck from the body.

The edges of the beak turn up

Anas platyrhynchos

46

A subtle palette on the head

The main colour of the male is grey and white. The stomach is sepia brown with violet glints visible close up. The head is dark green. Both male and female have an iridescent speculum (wing patch) between the blue and the violet outlined in white on the wings. The colours of the female are more subdued: a black line across the eye, wing and tail feathers dark brown with a white border. The underside is lighter and feet more orangey.

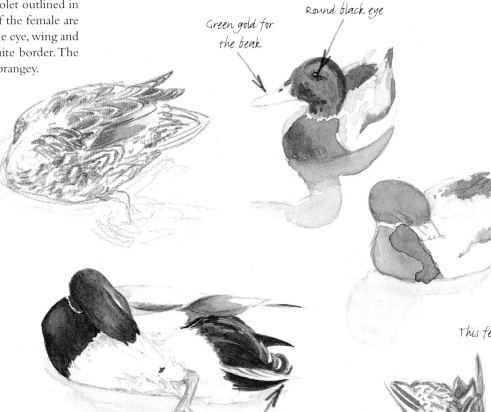

SAP GREEN

PAYNE'S GREY

BLACK

SEPIA

PERYLENE GREEN

GREEN GOLD

VIOLET

Round black eye

Green gold for the beak

On the male's tail the curved feathers make a pretty curl. The rump and the underside are black.

This female plunges her head into the water. Her rump in the air, she advances with her feet while eating underwater plants. These ducks are mainly vegetarians.

The submerged feet are rather blurred by their movements and the water.

The great crested grebe

It is in the display and mating season – April to July – that *Podiceps cristatus* is most easily seen, on slow-moving streams or in ponds, lakes or flooded gravel-pits. Later the great crested grebe is more subdued; some stay put while others migrate so it is best to take advantage of the mating season to observe them.

Bird love

The mating display of these birds is magnificent, and rather noisy! They dance in couples, dive together, rub together, the whole body and neck stretched out, breast against breast; then they turn their heads together in the same direction in a frenzied dance. They make each other offerings of seaweed and reeds.

Brown on top and white below the neck, the grebe in springtime displays a ruff of black and red feathers in the shape of a fan at the sides of the head, contrasting with the white cheeks. It is easily recognised, with its mobile double crest, its long pointed beak running in a straight line from the head, and its long, thin neck. Unlike the ducks, its body is almost three-quarters submerged, and it glides through the water like a submarine.

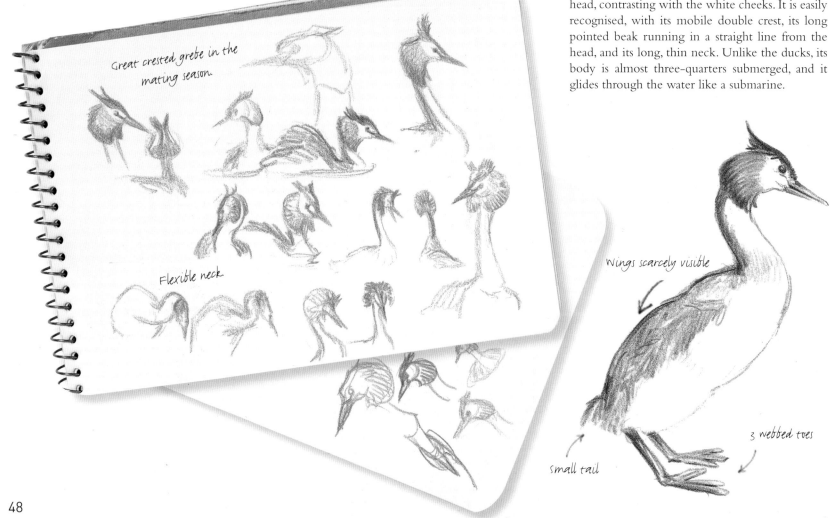

Great crested grebe in the mating season.

Flexible neck

Wings scarcely visible

small tail

3 webbed toes

Drawing in red chalk

I quite like the technique of drawing in red chalk, though on the other hand I prefer to work in pencil where I can sharpen it to a point to record precise details. Chalks break and finish up in a messy dust over all the things they are stored with. Moreover, like all pastels they need a fixative. Red chalk offers an assortment of earthy colours: browns, ochre-beige and orange.

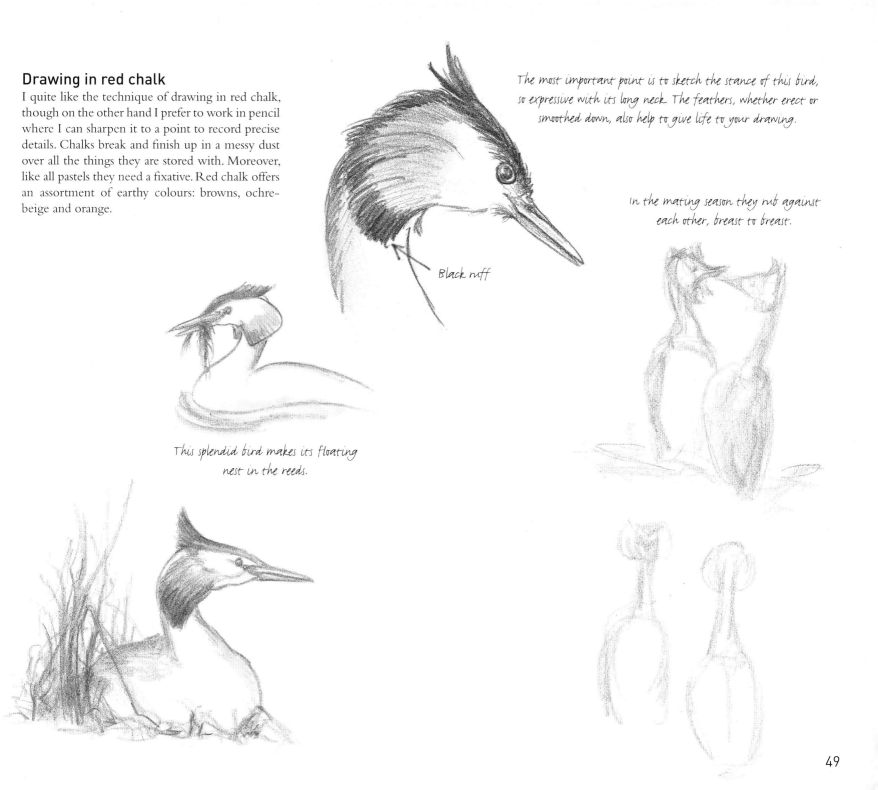

The most important point is to sketch the stance of this bird, so expressive with its long neck. The feathers, whether erect or smoothed down, also help to give life to your drawing.

In the mating season they rub against each other, breast to breast.

Black ruff

This splendid bird makes its floating nest in the reeds.

The grey heron

Herons can be found almost anywhere where there is shallow water and something to catch: fish, reptiles, fledglings, frogs and toads, insects... Their numbers have stayed constant and they are in good order, in spite of the gradual disappearance of watery habitats.

This great vessel taking off is always impressive. In full flight it folds its neck into a Z!

A great wader

Ardea cinerea measures about 95cm and weighs 1.9kg. Its long wader's legs are green and grey, with three toes in front and one behind. It has a long neck, grey on top and white underneath. The long beak is greyish orange, but the colour varies. At the back of the head, at eye level, two black nape feathers echo, at mating time, the long wing feathers and the little ones along the neck. The beak is a prolongation of the head and the eyes are just above the corners of the beak.

The stances of the heron, accentuated by the long neck, are very interesting. The more time you spend observing and making quick sketches, the better the drawings will be as regards proportions and recording its positions.

My sketches are blue – it's my choice. I find it's a colour that goes well with the heron. In reality the plumage is a little greyer, but this grey is more or less bluish depending on the light.

The stances of the heron, accentuated by its long neck, are very interesting.

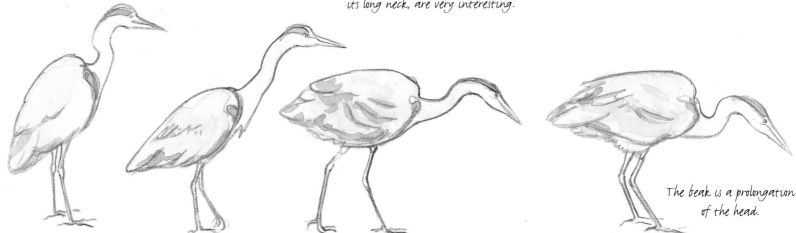

The beak is a prolongation of the head.

Colours of the heron

I try out my blue tint to find out what goes best. I use cobalt blue, very diluted for the whole bird, except the beak, head and front of the neck. Payne's grey, mixed with black, is perfect for the darker feathers. I always have a piece of paper on hand to test the colour and the amount of water before applying it. I shape the feathers by holding the brush so as to make rounded shapes.

For the eye I use light azomethine yellow circled with black (1). For the beak I use yellow ochre (2) and permanent orange (3), suitably diluted.

YELLOW OCHRE

PERMANENT ORANGE 3 2

LIGHT AZOMETHINE YELLOW

1

The eye is circled with black.

At mating time a crest of black feathers hangs down behind the head.

Long white feathers on the breast, which move in the wind.

PAYNE'S GREY

swollen foot

COBALT BLUE

For more than a year this heron has been coming almost every day to the botanical garden at the Museum of Natural History, Paris looking for fish in the pools. That morning, he had a swollen foot and limped a little. It has since got better!

51

THE OPEN COUNTRY

With the consolidation and parcelling up of land, a lot of embankments and bramble patches have disappeared from the countryside, and intensive farming does not really contribute to the conservation of biodiversity. At the same time, there is still interesting flora and fauna to be observed. As hiding places become rarer, you will be spotted from a long way off – discretion is necessary.

To sketch rapidly, I can place the leaf on the paper and draw round the shape with an HB pencil. In this way I can be sure the proportions are correct and that no little tooth in the margin will be forgotten.

The seed head has a plume

The seeds heads are grouped into a fluffy globular ball. Each seed is a fruit..

Deeply toothed margin

The stem is round in section.

Tarascacum officinale

The meadow sun

The dandelion is an easy plant to recognise, with its deeply toothed green leaves to which it owes its anglo-saxon name (from old French *dent-de-lion*, lion's tooth). It is a perennial, growing in full sun or semi-shade, with a taproot. Its yellow flower consists of many little florets gathered together in a composite flower head. After flowering the clocks appear, which contain the single-seed fruits of the dandelion. They are so light that a simple breath of air takes them away.

Drawing the flower head

I start with an elipse mounted on an axis which is the stem. Be careful if you want to paint it, as yellow is a very difficult colour. Do some tests before putting it down on paper, for the lighter the yellow, the more it risks being muddied by other colours. You also risk showing pencil drawing underneath.

1 I dab the pencil marks with a bread rubber to remove as much graphite as possible, while still being able to see the lines of the drawing. Then I apply lemon yellow (the palest) on each petal.

2 Once it is dry I accentuate and outline the petals with medium azomethine yellow.

3 To create a shadow which will be warm without muddying this yellow (as would a blue or grey) I colour with quinac gold at the point where the petal is attached, and between each petal. To shade, I apply it visualising
a bowl shape rather than a
round flower head.

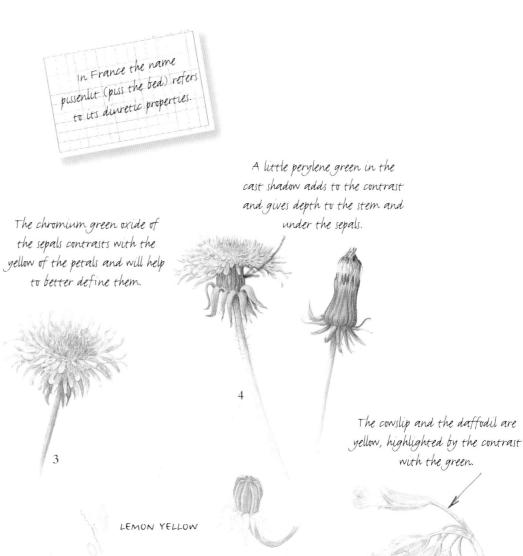

In France the name pissenlit (piss the bed) refers to its diuretic properties.

The chromium green oxide of the sepals contrasts with the yellow of the petals and will help to better define them.

A little perylene green in the cast shadow adds to the contrast and gives depth to the stem and under the sepals.

The cowslip and the daffodil are yellow, highlighted by the contrast with the green.

LEMON YELLOW

MEDIUM AZOMETHINE
YELLOW

QUINAC GOLD

The wild blackberry

The bramble, *Rubus fruticosus*, is a thorny shrub belonging to the rose family. Bramble fruit is the fruit of any such plant, including the blackberry and raspberry, but in the UK it mainly refers to the blackberry bush. Bramble bushes have a distinctive form, sending up long, arching canes that do not flower until the second year. These canes have thorns, sometimes recurved thorns that dig into clothing and flesh when you try to pull away.

Take your time. The stems will stay fresh in a vase for several days, allowing you to quietly make a fine illustration.

Roses and blackberries have thorns, often recurved thorns that seem to be 'placed' on the skin of the stem.

1

2

3

4

How to draw the stem

Use green gold, sap green, perylene green, sepia, permanent orange and burnt sienna.

1 After making a quick drawing, placing the thorns in the right direction on the stem, I apply a light wash of sap green, leaving out the areas of the thorns, especially if they are lighter.

2 The base colour of the thorns is permanent orange mixed with burnt sienna.

3 I refine the thorns, making them more pointed, and retouch the points with sepia, using very little water and a very fine brush. If the point of the thorn is darker, once the paper is dry I can go over the point of each thorn with a well-sharpened pencil or a pen with a very fine nib.

4 Finally, I add the shadows. A bramble bush is often very thick, and the more you look into its depths, the darker it seems. I add a light wash of perylene green over all the stems as a background.

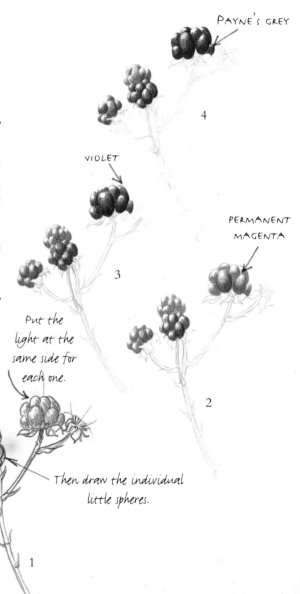

PAYNE'S GREY

VIOLET

PERMANENT MAGENTA

4

3

2

1

Put the light at the same side for each one.

Then draw the individual little spheres.

First draw a sphere.

An aggregate fruit

The fruit is not a true berry: it is called an aggregate fruit, as each grain or unit is really the true fruit, a little like the wild strawberry (see p.84). The leaves are composite, with 3–5 leaflets, while the flowers, white to pink, have five petals and many stamens.

Despite increasing land clearance, brambles are still flourishing almost everywhere and provide a safe shelter for many small animals and birds.

How to draw the bramble

First draw the general shape of a sphere, consisting of smaller, very smooth spheres. The fruits are shiny and plump: it is the light on each little sphere that we see. Remember to put the light on the same side of each little sphere. For the colour, three superimposed tones can suffice: permanent magenta, violet and, for the shadows, Payne's grey. Treat each little sphere separately.

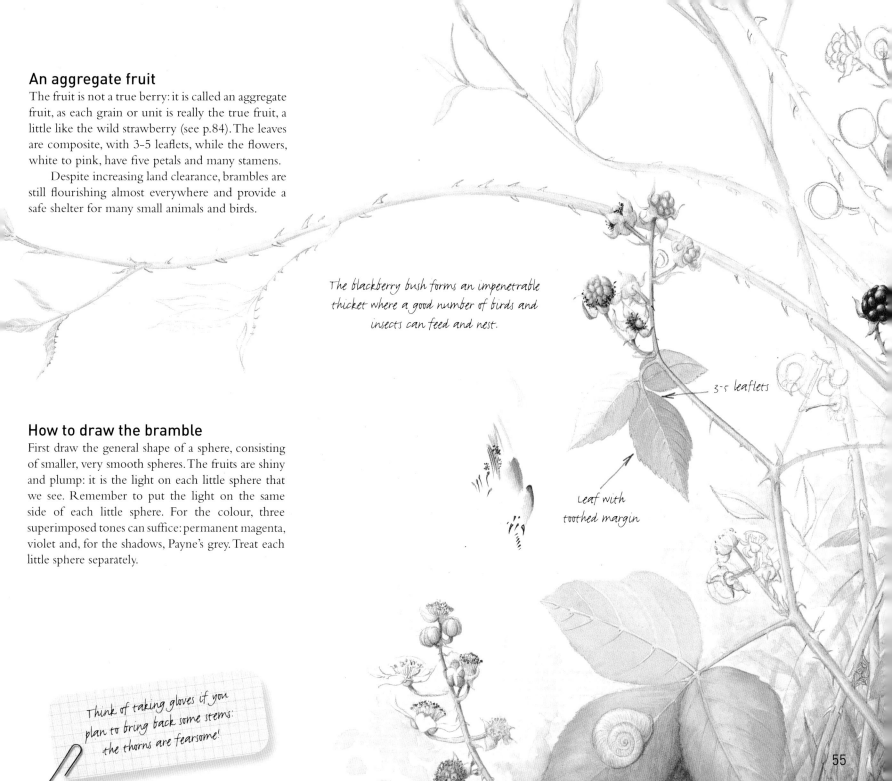

The blackberry bush forms an impenetrable thicket where a good number of birds and insects can feed and nest.

3–5 leaflets

Leaf with toothed margin

Think of taking gloves if you plan to bring back some stems: the thorns are fearsome!

55

Butterflies

Butterflies are part of the lepidoptera family, meaning literally, wings with scales. The wings are in fact covered with a multitude of tiny scales, arranged like the tiles on a roof. Taking account of this peculiarity, the technique of applying dry paint in little touches lends itself well to rendering the colours of butterfly wings.

In your garden and terraces, think of encouraging diversity by choosing native plants that will attract butterflies. You will then have the pleasure of seeing them at work

The upper wings are a little bigger than the lower ones.

On the thorax, 6 legs and 2 pairs of wings

CABBAGE WHITE, *Pieris rapae*

CLEOPATRA BUTTERFLY
Gonepteryx Cleopatra

Where can you sketch butterflies?

Diurnal butterflies are often very attractive because of their vivid colours. Nocturnal ones, and moths, are more discreet and tend to have protective colouring to prevent falling prey during the day, when they are inactive.

When butterflies are at rest, or sheltering from the rain under some leaves, wings closed, they are easier to observe, but the underside of the wings is less brightly coloured. In any case, be observant – in nature butterflies go from flower to flower in search of nectar, often much too quickly to enable you to do a very finished sketch.

You must therefore choose at the outset: either to sketch the outline and position of the insect in two or three pencil lines, leaving out any details, or to interleave observation on the ground with photographs and preserved insects to achieve an ensemble which is at the same time alive, unique and belongs only to you.

How to draw a peacock butterfly

1 I draw half the butterfly, making sure to define all the different colour zones, marking the veins. Then I trace it out and put it on the other side. Thus I have two identical wings and a butterfly that could fly!

2 I dab the pencil with a bread rubber, then I apply a light wash on the different zones to distinguish them easily. I start with the lightest colours, in order not to forget them, but be careful: they are also the most likely to become muddy. So I start with lemon yellow, permanent orange and burnt umber.

3 I start with the ocelles (which look like the eyes), working on one after the other, paying attention to their placement as mirror images. Then I apply cerulean blue, permanent magenta and crimson lake.

4 I finish with the red, then the black, and I begin to bring out the highlights.

5 Once the paper is dry I change technique, using less water, and I dab with my brush (N° 00), using little touches, to give texture to the scales (see also p.23). The bottom of the wings and the body are covered with hairs: I draw my brush in the same direction to make lines. On the wings the hairs lie towards the bottom; on the body they more resemble fur.

6 I add the details gradually, always dabbing with an almost dry brush, so that the transition between the different colours is achieved without a definite line, so it looks more like scales. The brown specks are in sepia.

7 The hairs at the bottom of the wings have a red base to which I add brown little by little, in small lines, to give depth to this growth.

8 I add the shadows on the right side of the butterfly with sepia and a little water, I draw a fine line between the two parts of the wing so that visually the upper wing is seen first. With the same colour I enhance the crinkled borders of the wings and the antennae. I colour the eyes, giving an identical light to each one – this gives some life to the butterfly.

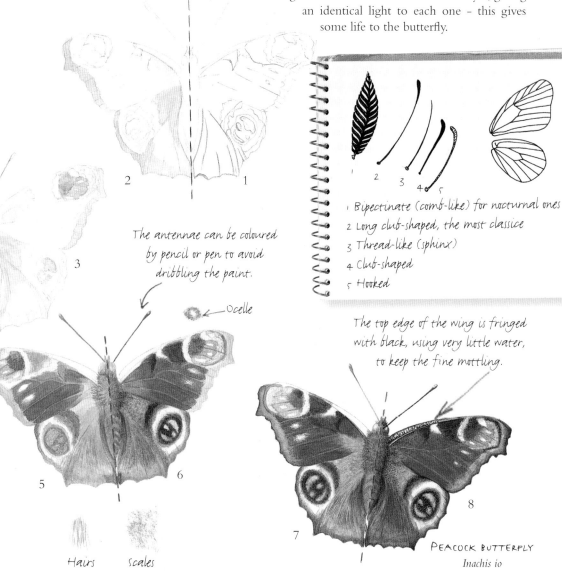

The antennae can be coloured by pencil or pen to avoid dribbling the paint.

Ocelle

1 Bipectinate (comb-like) for nocturnal ones
2 Long club-shaped, the most classice
3 Thread-like (sphinx)
4 Club-shaped
5 Hooked

The top edge of the wing is fringed with black, using very little water, to keep the fine mottling.

Hairs scales

PEACOCK BUTTERFLY
Inachis io

57

Small insects

The basic structure is the same for all insects: head, thorax, abdomen and legs. Thanks to their diversity we have the opportunity to draw these little marvels, sometimes a little comical but always very surprising.

The large green grasshopper

The green grasshopper, which can measure 5.5cm, is quiet and almost invisible in the long grass of the fields and at the sides of the road. It is sometimes called the sword-jumper because of the egg-laying organ of the female. Unlike the cricket, it has large, movable antennae. Mainly carnivore, it has large jaws and can pinch you if you catch one. If you approach quietly, without making sudden movements, you can observe it unseen.

Rapid sketches are always interesting and useful for understanding its structure and the proportions of its long back legs. Try to draw all the legs: that positions the insect and gives it a more lively appearance. Whether it is facing you or viewed at three-quarters this jumper is rather long. Face on, therefore, you have to draw it foreshortened. Geometric shapes without details can simplify and make it easier to understand this perspective.

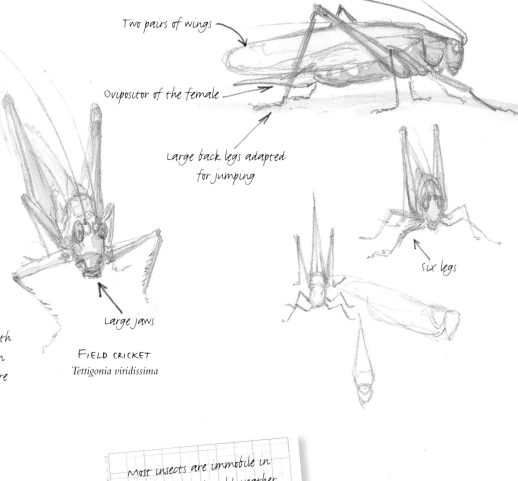

Two pairs of wings

Ovipositor of the female

Large back legs adapted for jumping

Large jaws

six legs

FIELD CRICKET
Tettigonia viridissima

Pencil sketch on paper, with a light wash of sap green for the ensemble and ochre yellow for the top.

Most insects are immobile in the morning, or in cold weather. Take advantage of this lethargy to observe them!

The seven-spot ladybird

The ladybird is so well known that you only have to draw a red sphere with black spots to indicate one. There are numerous species, differing mainly in colour, size and the number of spots on the wing cases. The most common is *Cocinella septempunctata*. Red, smooth and shiny, it has seven black spots on the wing cases, hence its common name, the seven-spot ladybird. The rest of the body, including the head, is black.

The structure of this insect does not allow for a very mobile drawing: only the antennae, legs and wing cases can move. The problem then lies not with posture but with colour.

1-2 To show its shiny appearance, I keep a light on the wings, and I use two different reds to give depth. The first is light permanent red.

3 Except for the shiny area, I apply light permanent red which is slightly orangey for the whole wing cases, and then on top I apply dark permanent red on the areas not highlighted, to give depth and volume.

The curve of the wing cases is shown in three-quarters, so we cannot see all the legs at the same time, as opposed to a view from above or below.

spiders have 8 legs and are not insects but arthropods. They are very useful, so don't kill them: they are part of the ecosystem.

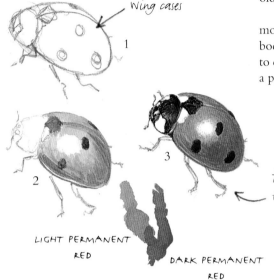

Wing cases

1

2

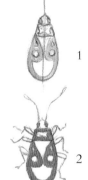

3

LIGHT PERMANENT RED

DARK PERMANENT RED

The firebug

This bug, 12mm in length, is the most widespread in Europe, colonising almost all habitats, except the mountains, though it is rare in Britain. In France it is known as the '*gendarme*' as its colours recall the old red and black uniform.

Like the ladybird, *Pyrrhocoris apterus* only has mobility in its legs and antennae. The rest of the body is stiff and symmetrical, so that you only need to draw one side, then copy it on the other, to have a perfectly realistic '*gendarme*'.

The legs are finished off with the nib of a pen.

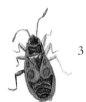
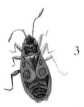

1

2

3

4

1-2 I apply two coats of orange.

3 So that the water doesn't mix the two colours, I wait till the paper is quite dry before applying the black.

4 I paint the support the bug is resting on, and I add the shadow that it casts. Then, when the paper is quite dry, I paint on the legs and antennae with a fine brush or pen.

For flying insects, or where 2 pairs of wings are visible in coleoptera like the stag beetle, the first pair are transformed into wing cases.

The common toad

A bit ungainly with its short little legs, squat body and pretty golden eyes
– what a marvel! I have always liked amphibians, but *bufo bufo* will always
have a special place in my heart. Its call – croak croak – announces the
start of the fine weather.

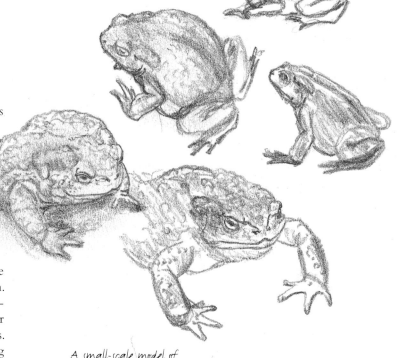

An efficient insectivore

Found everywhere, on plains, in forests, gravel-pits
and thickets, it returns near water to reproduce.
It is easy to find them during the day,
otherwise you have to look for them
under stones, or at night when they hunt
for insects. They hibernate from October
to March in holes, under stones or under
tree stumps. If you have a garden it is
important to leave a heap of wood in a corner
where they can hide.

It is the biggest of the toads. The females are
bigger than the males, measuring 15cm in length.
Their skin is covered with pustules – bumps-
which you must include because they are, together
with its squat shape, one of its main characteristics.
The back is brown-grey, ochre to olive according
to the individual, with a lighter underside, more
or less spotted. You can touch it: it has a venom
but doesn't secrete it. The venom is only dispersed
when a predator bites the toad, piercing the skin.
The skin is not moist like that of the frog or
salamander, and it is not shiny, but matt.

*A small-scale model of
the toad emerging from
the water.*

*It lays strings of eggs in the water. As
they develop these become tadpoles. They
metamorphose little by little: back legs
emerge and then front legs, and then
the tail disappears.*

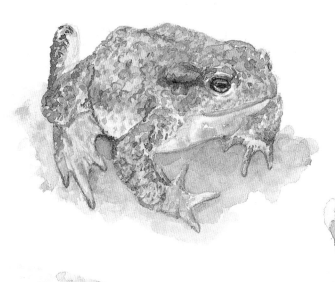

Faced with a predator it puffs itself up and rises up on its legs to seem bigger and so discourage it.

The eye is golden, more or less coppery, with horizontal pupils.

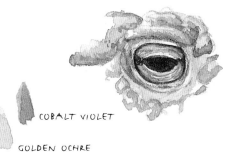

COBALT VIOLET

GOLDEN OCHRE

YELLOW OCHRE

SEPIA

AZOMETHINE YELLOW

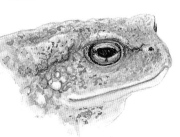

To give body to the pustules you must darken them on the side away from the light, like an upturned bowl.

Colouring the toad

After colouring the whole toad in yellow ochre, I add sepia to the markings while the paper is still damp. Then, when the paper is dry, I add sepia to the bumps and their contours, and the darker area such as under the legs or the ends of the toes. To colour the iris of the eye without saturating it, I start with the yellow, which will stay underneath to lighten the whole. Then I apply golden ochre with a fine brush, following the curve of the eye, but without covering the yellow totally. I accentuate the rounding of the pupil with cobalt violet, which is golden and warm. When the paper is completely dry I encircle the eye with a fine No 00 brush and colour the lens black.

The wall lizard

This is the curious little creature perched on low walls or piles of stones, looking at you with its head to one side. This little lizard, about 20cm long, has a long tail which accounts for more than 60 per cent of its body. It eats great quantities of insects, but is often itself eaten so it is in the habit of darting away rapidly. If you want to watch it, don't make sudden movements.

5 toes on the front and back legs.

The 4th toe is longer than the others.

Stone grey colour

The basic shape of *Podarcis muralis* is the same as that of the salamander (see p.38), but it is much slimmer. The nose is pointed, the legs have 5 toes, each ending in a claw. Apart from the eye, the lizard is entirely sepia coloured, with different gradations. The great variation in its colour can confuse identity. On the back, it can be grey and black, brown, sometimes with green patches, while the underside is lighter, with yellow, orange or blue.

SEPIA

Anus is just behind where the legs are attached.

Eardrums

YELLOW OCHRE

Be careful: lizards and slow worms have the capacity to shed their tails voluntarily, in order to create a diversion and escape from predators. Even if the tail regrows, it is never as good. It will stay atrophied, lifeless and without scales so try to avoid capturing one.

The slow worm

Anguis fragilis is a kind of legless lizard found all over Europe. It is found in all kinds of habitat, wet as well as dry. I have often found them under tree stumps and stones. It eats insects, mostly larvae, slugs and earthworms. It is ovoviparous, mating from April onwards, and the young are born from August onwards. Sometimes it hibernates in groups, in holes or burrows.

An easy subject to draw

The head resembles the lizard's, while a little rounder, and the eardrum is not visible, entirely hidden under the scales. The body is cylindrical, ending in a long tail rounded at the end. The male is a uniform colour that shades from grey to brown, passing through ochre, greyish bronze, reddish and even slate tones.

The female, which is larger, has dark sides and brown lines on its back. Apart from those of the head, the body scales are small and smooth, all identical. The shape is very easy to draw: a sausage which narrows near the tail and then stops abruptly. It has small eyes with eyelids and and two nostrils. The main colour is ochre, while the sides, vertebral line and shadows are sepia.

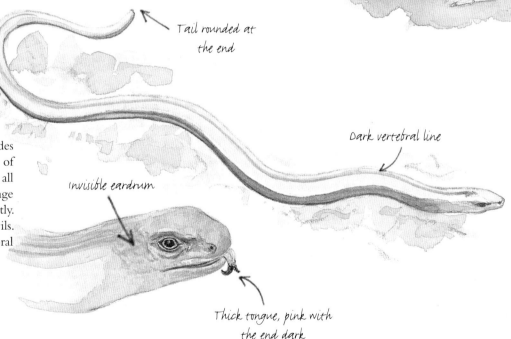

Head and muzzle, which is conical and rounded

Tail rounded at the end

Dark vertebral line

Invisible eardrum

Thick tongue, pink with the end dark

The aesculapius snake

This is considered one of the most handsome snakes and was the emblem of doctors and pharmacists shown on the staff of Hermes. Long (about 1.5m) and slim, it is one of the largest snakes in Europe, though rare in Britain, and can reach 2m.

To sketch the snake

The colour varies according to the individual and can be brownish-green olive, or sepia with a yellow underside that could shade to ochre. Active by day and at twilight, *Elaphe longissima* is found in forests and woodland clearings, and on footpaths and low, dry, sunny walls. It mainly eats rodents, but though it lives on the ground, it does not balk at going up trees to hunt birds. The young snakes have a V mark on the nape like the grass snake. It likes the heat and hibernates early in autumn, emerging in mid-spring, at the mating season.

After having roughed out the whole head, I put in the eyes, the nostrils and the largest scales on top. I then add the details: the round pupil, the scales, smaller from the neck down.

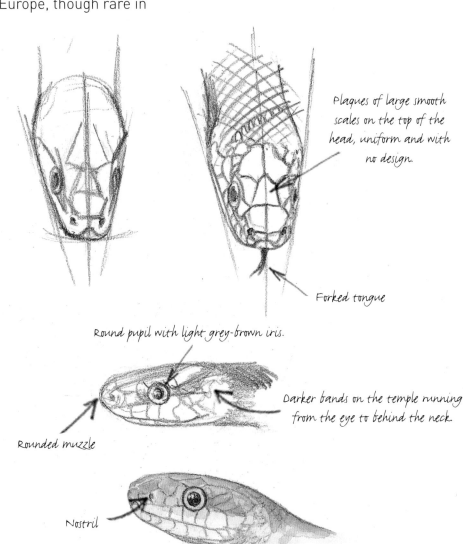

Plaques of large smooth scales on the top of the head, uniform and with no design.

Forked tongue

Round pupil with light grey-brown iris.

Darker bands on the temple running from the eye to behind the neck.

Rounded muzzle

Nostril

slim head with few marks on the neck.

Choose a composition

Considering the size of the snake, a view of the whole does not permit putting in the detail of all the scales, unless you have a large sheet of paper and draw from photos, because the snake won't have the patience to wait. There are two drawings possible: either the whole snake with very little detail, or details shown in close-up.

The snake isn't stiff and straight: to show the curves and undulations you must start with a median line which is the central axis, and then the two lines which define the length of the body.

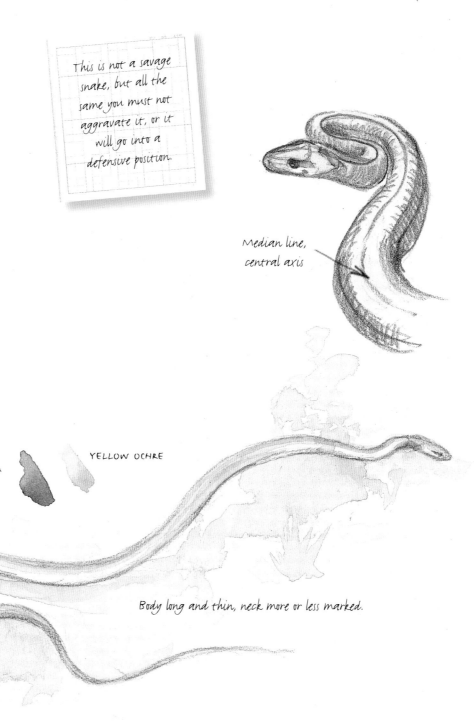

This is not a savage snake, but all the same you must not aggravate it, or it will go into a defensive position.

Median line, central axis

SEPIA

YELLOW OCHRE

Body long and thin, neck more or less marked.

Hermann's tortoise

This tortoise is found all over southern Europe, including France, Spain, Corsica, Italy, Greece and Turkey. Its natural habitat is the dry steppes and plains.

Very fond of fruit

Like all reptiles, it is reliant on the outside temperature. In summer, when it is too hot, it hides in crevices in the ground, and before the winter it digs a hole to hibernate. It is especially active in good weather – in the morning after the sun has warmed it up, and at the end of the afternoon when the sun is going down. It is at these moments that it can most easily be observed. It goes off looking for flowers, leaves, fruit and invertebrates such as worms or snails. It is a solitary creature, but faithful to its territory; one can quickly learn its habits without disturbing it. It will stay immobile while it eats a tomato or plum, long enough for you to be able to draw it. Its yellow ochre colour and its dark brown or black markings enable it to blend into its surroundings.

The male has a longer tail and is slightly smaller than the female, which can measure up to 25cm as an adult. In the mating season it is easy to tell them apart: the male is demonstrative, either scuffling with a rival or harassing the female, pushing her and knocking violently against her shell.

YELLOW OCHRE

SEPIA

BLACK

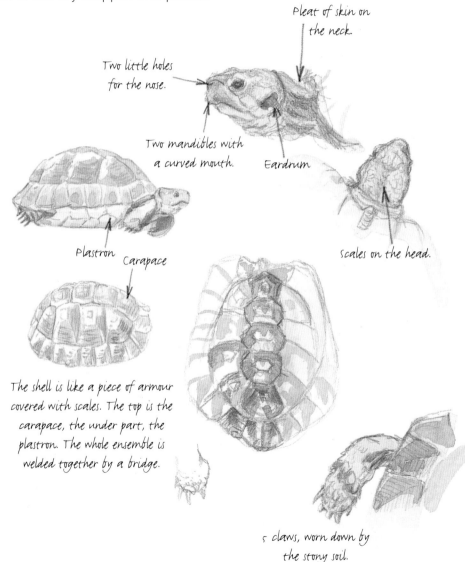

Pleat of skin on the neck.

Two little holes for the nose.

Two mandibles with a curved mouth.

Eardrum

scales on the head.

Plastron Carapace

The shell is like a piece of armour covered with scales. The top is the carapace, the under part, the plastron. The whole ensemble is welded together by a bridge.

5 claws, worn down by the stony soil.

Painting the carapace

The structure of the carapace that protects the body is very symmetrical. Even if the size varies according to age, the position of the scales is always identical. It is a rigid structure, and the only movable parts are the legs, the head and the tail. At the top. 5 large scales situated at the centre divide the carapace into 2 equal parts. If the carapace is seen from the side, don't forget to retrace the furthest away side. This helps to add volume, thanks to perspective.

The marks are rendered by a mixture of sepia and black, but be careful, the colours change according to the region they come from and their sub-species.

1 I draw in pencil, not rubbing out before applying paint, as the scales of the tortoise are very textured by stratification lines.

2 I use a light wash of yellow ochre with a sepia base to colour the whole tortoise, applied with a fine brush. I indicate all the growth marks on each scale.

YELLOW OCHRE

SEPIA

BURNT UMBER

BLACK

5 I outline the claws and the scales on the legs.

3 Then I mark the dark patches, diluting the pigment so it is not too dark, as the carapace is matt.

6 Finally I add burnt umber on the bottom corners of each scale, to add volume.

4 With a pencil I mark more of the growth marks where there are not enough.

At birth the carapace is soft. It hardens with age.

It retracts its head and legs to sleep, or to protect itself against predators.

Robin redbreast

The robin is a little bird well distributed over most of Europe. It frequents forests, parks and gardens and is even found in towns. It largely lives on insects, but in winter it depends on berries and grains. Put some feed in a bird feeder to watch it easily.

Buy a well illustrated ornithological guide for quick identification. Make it small and light, so it will fit in your pocket.

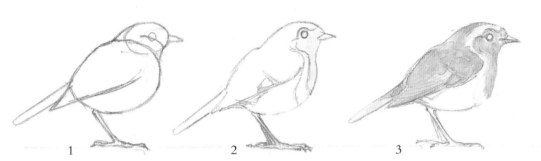

1 2 3

Subtle colours

With its beautiful red-orange breast and round, dark little eyes the robin is easily recognisable. The stomach is pale grey while the wings, tail and back are a mixture of brown and olive green. Its beak, conical in shape, is dark brown, lighter at the bottom, The young don't have orange colouring and their feathers are sprinkled with brown.

1 All little birds are made in the same way (see p.18). The variations appear according to the size of the bird and at the level of the beak, the legs and the tail. After having drawn the main shape, I dab and I add the characteristic details of this variety, then I put on the colour.

2 I start with of a foundation of medium azomethine yellow.

3 On top, with little strokes to give the effect of feathers, I put on permanent orange. Around the eye is lighter. At the side of the orange, the feathers are grey, more or less bluish according to the light. For the brown, I use sepia, quite diluted, and as soon as the paper is dry I add olive green in little touches to add body.

4 Then, when it is all quite dry, I add the black to the beak and eye, not forgetting to keep some white for the glints.

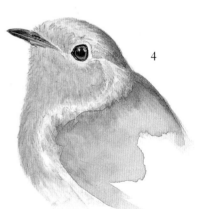

4

MEDIUM AZOMETHINE YELLOW

PERMANENT ORANGE

Test area to find a good tint.

SEPIA

MIXTURE OF CERULEAN BLUE AND BLACK

OLIVE GREEN ON SEPIA

The sweet little wren

Troglodytes troglodytes is a miniscule insect-eating bird, round, very energetic, which hops from branch to branch. It likes cavities in rocks and hollows in trees, which is how it came by its name. It can always be recognised by its little tail raised vertically. It has a fine beak and brown plumage. Its flight is nervous, fitful and hedge-hopping.

YOUNG WRENS

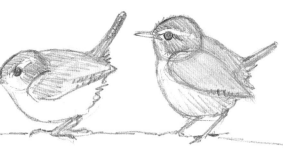

When the head is down, the legs are not visible.

In all other positions, always draw the two legs to position the bird well and adapt the feet to the support.

Like the robin, the bullfinch has a richly coloured throat and breast, but with a pinky red. Its beak, large and strong, shows that the bird mainly eats grains. It is a major identification characteristic and I make sure to draw it well.

The vivacious one

It is sweet, but so lively that the most simple way to capture its movements is still photography, doing the drawing later. Apart from the white band across the eye, I colour it entirely with ochre. The top is darker, so I do another coat in sepia, particularly at the bottom of the eye, on the wings and the tail, making sure to keep some little bands less dark on the edge of the last wing feathers and on the top of the tail.

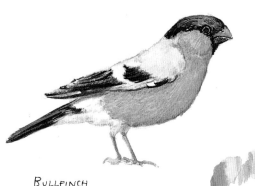

For the red of the breast, I use the same technique as for the robin, but with light permanent red on top of the permanent orange.

BULLFINCH
Pyrrhula pyrrhula

PERMANENT ORANGE

PERMANENT RED

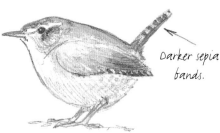

YELLOW OCHRE

SEPIA

Darker sepia bands.

The tit

Two small spheres, a little eye, round and black and there's a tit. It only needs a beak, legs and some colour to bring it to life and identify it.

Blue tit or coal tit?

The coal tit has black on the top of its head, white cheeks and a greenish back. A black bib starts under the beak, contrasting with the yellowy-green that covers the abdomen. The wings are bluish grey with two white wing bars and the tail is the same grey with white rectrix feathers. The legs are light grey.

The blue tit can be recognised by its blue cap and by the dark blue line that goes across the head. The blue-grey beak is small, conical and pointed. The body is greenish brown on top and yellow underneath, with a grey median band less marked than on the coal tit. The wings, tail and legs are blue.

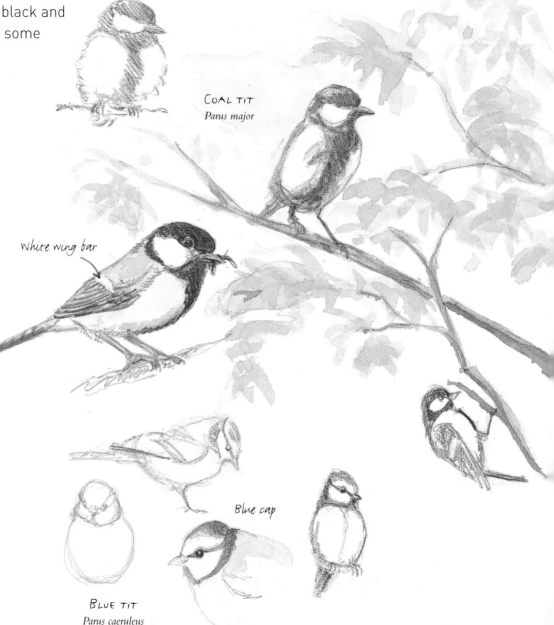

COAL TIT
Parus major

White wing bar

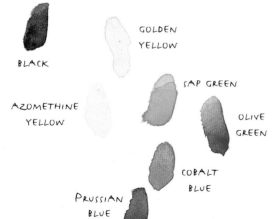

BLACK

GOLDEN
YELLOW

AZOMETHINE
YELLOW

SAP GREEN

OLIVE
GREEN

COBALT
BLUE

PRUSSIAN
BLUE

Blue cap

BLUE TIT
Parus caeruleus

Drawing a coal tit's nest

The tit makes its nest in holes in rocks, walls or posts, sometimes even in letter boxes. The nest, flexible and soft, is made out of pieces of grass, roots, moss, leaves and even animal hairs. The fibres are all intermingled and that must be shown in the drawing.

1 I sketch the nest in the shape of a bowl. If I keep this shape in mind from the start, it will help in placing light and shade.

2 First of all I draw the twigs on the top of the nest, without making them too dark. A light wash of green ochre is enough to colour them. With burnt sienna I darken little by little around the twigs to make them stand out.

3 I also darken the twigs in the background with a sepia tone.

4 A light wash of sepia at the bottom of the nest enables me to hollow it out visually by making it darker.

5 The moss incorporated into the nest is a little lifeless; it is dry because it is an old nest found on the ground. I choose olive green and terre verte to colour it with little strokes. I darken the hollows and outline the stalks with sepia to give body to the moss.

YELLOW OCHRE

SEPIA

BURNT SIENNA

OLIVE GREEN

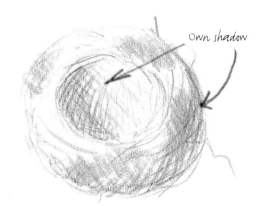

Own shadow

The twigs are flexible and go off in all directions except in the centre of the nest where they are more interwoven.

To show that the nest is standing on something, I add a cast shadow, always in sepia to keep the same tones.

71

The blackbird

Blackbirds can become very familiar in the garden. Every time I am digging or planting something, a curious little creature comes up, less than 4 metres away, and claims a worm from me. They like to sunbathe in the morning, and stay still long enough to be sketched.

speak to ornithologists – they are enthusiasts who will be delighted at your interest, if you show you can be calm and silent.

Sketching the blackbird

The adult male is entirely black, with the beak and circle around the eye orangey-yellow, contrasting with the jet-black plumage. The female, all in shades of brown, has a lighter abdomen and a beak that is two-coloured, brown and pale yellow.

I had the good luck to be present when the ornithologists at the Museum captured a bird for observation. This fine female blackbird, caught in a net, was weighed, measured and ringed. Its beak, very orangey for a female, was worth several photos which I used to complete my rapid sketches of the procedures.

Pencil serves as the base colour. In order not to forget the orangey-yellow around the eye and on the beak, I put that on first, being careful that it won't run into another colour, as I don't have time to wait till it dries. I add sepia for the brown plumage of the female, and a little black to darken certain areas. See the wing on page 94 for more details.

I used permanent orange for the beak and the circle around the eye. The feathers are painted with a fine N° 00 brush. The darker they are, the more I add sepia, making little strokes that follow the shape of the feathers. Try to avoid putting on too much paint all at once, because you risk smoothing it all out. The eye is brown-black, but I keep a white patch to create a bright glint that gives it life.

The drawing of the blackbird's head is entirely done from the photos taken during her capture. I could see by her eye that she was panicking, so it was useless to add to her stress – the drawing could wait.

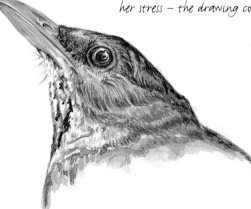

The beak, with the thick, soft, yellow edging, is characteristic of young birds.

A young blackbird in the nest

This young blackbird has hardly left the nest and, by his way of holding his beak in the air without moving, it is obvious that he knows I am there but thinks that he has not been spotted.

In order to be able to draw without frightening him, I keep at a distance, so that I can do several sketches. I quickly sketch the outlines of the bird before adding as many details as possible.

The beak, with the thick, soft, yellow edging, is characteristic of young birds. I take care to draw this accurately. In this position we don't see the wings, or the tail, but I know that they are proportionally smaller than those of an adult bird.

I put a light ochre wash over the whole little bird, except for under the throat, the eye and the point of the beak. I wait until the paper is dry to add sepia mixed with burnt umber to the top of the head, the back and the edges of the little feathers. Once the paper is completely dry, I colour the eyes black, leaving a little white for the reflection. Last of all I draw his surroundings.

Do not disturb or pick up young birds that have fallen out of the nest, because, even if they are on the ground, the parents will continue to feed them. You can get information from the RSPB.

73

The chatterbox magpie

You often see it before you hear it, but this contrast in black and white does not pass unobserved. Very lively, as if mounted on springs, this elegant bird never stays still. It can be found everywhere, even in towns.

In winter, when the trees are without leaves, you can easily spot their nests. They are made with branches that stick out in all directions. They seem totally disorganised, but in fact the nest is covered with branches and has two exits.

A contrast in black and white

The general shape of the magpie is like that of the blackbird, but the beak is much more powerful and the body is a little rounder, ending in a long tail which it uses to balance. Make two spheres, one for the head and the other for the body. The abdomen and some parts of the wings are pure white, while the rest of the plumage is completely black. There is no transition between the two colours.

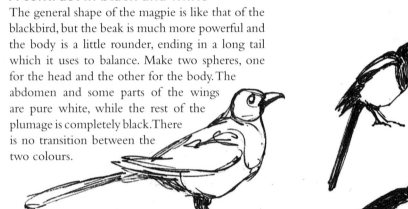

If you are drawing with a felt-tip pen, watch out for smudges of fresh ink.

Drawing with a ball-point pen

I love to draw with a ball-point pen: the ink doesn't spread, so it doesn't matter what quality of paper you use. The quantity of ink deposited varies according to the pressure used and the number of strokes. It is pleasant and easy to master.

1 I sketch the feather in pencil, not leaning too hard, taking care to show the different colour zones.

2 Always in the direction of the barb, from the inside to the outside of the feather, I go over the pencil marks with the pen, without ever going around the contour of the feather so as not to encircle it.

3 I rub out the pencil marks, after having assured myself that there is no deposit of ink that could smudge.

You have to practise drawing in this way. Learn to master how much pressure to apply and succeed in making parallel lines.

To make a barb, place the pen at the edge of the shaft and draw a line, then lift the pen gently so as to gradually stop the line.

For the down, the line must not be thick or opaque, but composed of scrolls more or less transparent. Lean with the pen as lightly as possible.

The pheasant

Phasianus colchicus is the most common and most widespread of all the pheasants in the world. Millions are raised for game shooting. They are found in open spaces such as arable land, edges of woods or forests. Omnivorous, they mainly eat grain, fruit and insects.

A real charmer

During its mating display it woos the female by letting one wing hang down at its side, by singing and batting its wings. It has many other preoccupations besides thinking about who is sketching in a corner! It doesn't run away, as it does when frightened, which helps to make a sketch on the spot.

On the male, the head and neck are iridescent green and blue, a white collar standing out against the chestnut-coloured body, with brown markings and glints of red and petrol blue, becoming violet at certain spots. Its long tail – 60cm – is golden brown, edged with black.

A base colour, then little touches superimposed, will give this appearance of glints on the neck. It is the same technique as that used for the butterfly's wings (see p.56).

For these rapid sketches I mark out the general shape of the body, paying attention to the proportions, such as the size of the tail in relation to the body or to certain details which help to recognise the breed. The female is smaller and less colourful: light brown spotted with dark brown and black.

He turns on the charm.

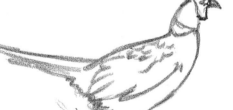

The eyes are golden and the beak is quite powerful.

The bumpy skin is shown by two successive coats of red.

The red-legged partridge

Two spheres, one for the head, the other for the body, and you have the essence of the partridge. Quite round, it is very attractive with its coral-coloured beak, legs and around the eye, under a white mark. The throat and cheeks are also white, bordered by a black band. The breast and the leg bars are grey-blue with black bands. The underside is orangey-ochre and the entire plumage looks as if it were painted on.

Where do you find the red-legged partridge?

You find this partridge in small areas, quite diversified but always dry and open, such as open farmland, pastures, and vineyard. When in danger it tends to stay immobile and flatten itself on the ground, rather than fly away. Thanks to its plumage, which makes an excellent camouflage, it can pass unnoticed at a few metres.

Unlike the pheasant, which has a harem and doesn't look after the young, the partridge mates from April onwards and the parents raise the young until the following spring. In winter, some families group together, with up to a hundred individuals in the group. It is easier to spot a group than an isolated individual, but there are so many pairs of eyes to give the alert if you are not careful. It feeds mainly on vegetation, but also insects. As it is hungry in winter, it is easy to spot very early in the morning if you regularly put down a little heap of grain in the same spot.

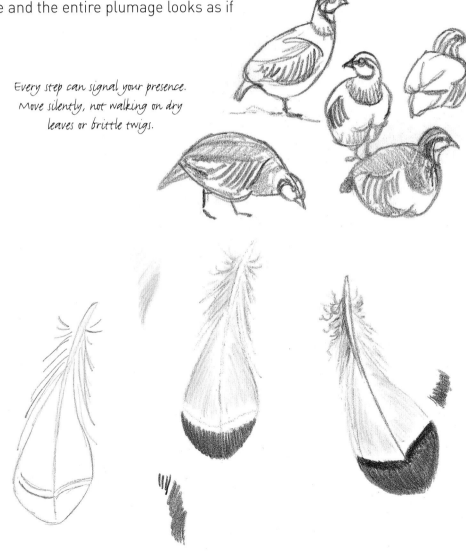

Every step can signal your presence. Move silently, not walking on dry leaves or brittle twigs.

The common buzzard

Very common in Europe, this bird of prey inhabits wooded areas and is often to be seen sitting on a fence post. You will have no difficulty in sketching it as it is big enough to be visible from far off and easily recognisable by its cry and its habits.

V for variable

It is also known as the variable buzzard because of the variation in colour of its plumage: dark brown on the back, it becomes lighter, almost white underneath, spotted with brown. It has a characteristic lighter V on its breast. The round head, short neck and beak gives the buzzard a rather compact profile. With its coppery yellow eyes and large talons it exudes a power unique among the birds of prey. The female is larger than the male. She hunts on demand, eating small mammals, birds, reptiles, amphibians, insects and carrion. She mates for life, and is therefore predictable to the hunters.

If there seem to be a lot of buzzards in the winter, it is because there are no leaves to conceal them, and also because some migrate from central Europe.

White V on the breast

50-60cm and up to 1.3kg

Buteo buteo

Lower leg

Tarsus

Large, stiff feathers

small and medium wing covers

Large wing covers

Primary flight feathers

secondary flight feathers

If you are making rapid sketches, it is best to start by positioning the head, which is more mobile, then the top of the wings and the shoulders. This will give structure to the bird.

Painting the buzzard in repose

1 The eyes are on the level of the corner of the beak. They are round, under a prominent eyebrow arch. It is a good reference point for the drawing. The beak is proportionately half the length of the head and is pointed downwards. I start painting the beak with medium azomethine yellow then light grey which is the base colour of the light reflection. I have decided from the beginning to reserve the white for the eye reflection.

2 To give a warm colour to the plumage, I am using burnt umber which I apply in little touches to tint the feathers. I darken the beak little by little, following the curve and without blunting the point. I darken the whole plumage, always with the same pigment and less and less water to gain precision. I colour the eye with burnt sienna.

3 Once the paper is dry I add sepia around the eye and on the points of the feathers to increase the volume. To finish, I gently circle the eye with black, then I colour the pupil, the point of the beak, the nostril and the corner of the beak, using a fine brush and a little water for precision.

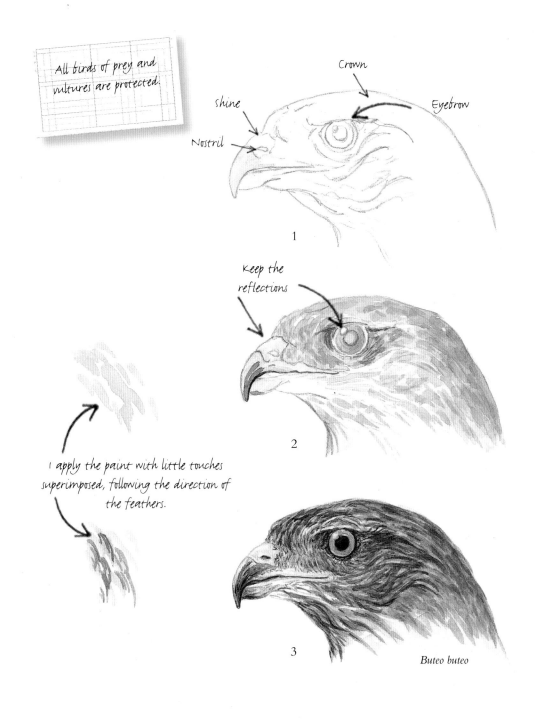

All birds of prey and vultures are protected.

Crown

shine

Eyebrow

Nostril

1

Keep the reflections

2

I apply the paint with little touches superimposed, following the direction of the feathers.

3

Buteo buteo

The European rabbit

Rabbits are everywhere! They have colonised the entire world thanks to their capacity for adaptation and their incredible proliferation. Although they are reputed to prefer twilight and night-time, they can also be seen in broad daylight, even on roundabouts in semi-urban areas and on airport runways...

The rabbit

Oryctolagus cuniculus measures up to 50cm long, its weight varying between 1.2-2.5kg. Its fur ranges from grey-beige to reddish brown and certain individuals sometimes have black or russet tones. The stomach is lighter and the underside of the tail is white. The fur conceals it perfectly from the eyes of predators, but not from draughtsmen who have been warned!

The only visible difference between males and females is in the shape of the head, which is smaller in the female. They reproduce all year round, but if you want to see the young, the births mainly occur from February to August.

study for the eye with a 2B pencil

In rabbits the ears are shorter than the head.

Keep a spot of light

Oryctolagus cuniculus

To draw the fur in pencil and vary the tone, you must vary the strokes and the pressure applied, leaving more or less graphite. A thicker deposit allows you to darken the patches and hollows of the ears, and to circle the eye, while leaving a white spot to mark the reflection of the light.

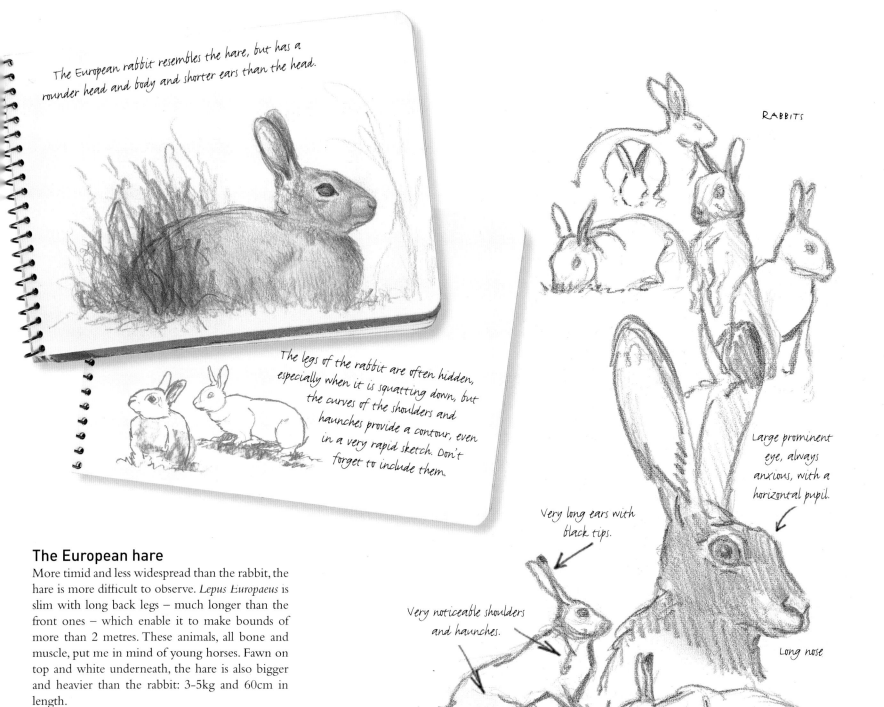

The European rabbit resembles the hare, but has a rounder head and body and shorter ears than the head.

The legs of the rabbit are often hidden, especially when it is squatting down, but the curves of the shoulders and haunches provide a contour, even in a very rapid sketch. Don't forget to include them.

RABBITS

Large prominent eye, always anxious, with a horizontal pupil.

Very long ears with black tips.

Very noticeable shoulders and haunches.

Long nose

EUROPEAN HARE

The European hare

More timid and less widespread than the rabbit, the hare is more difficult to observe. *Lepus Europaeus* is slim with long back legs – much longer than the front ones – which enable it to make bounds of more than 2 metres. These animals, all bone and muscle, put me in mind of young horses. Fawn on top and white underneath, the hare is also bigger and heavier than the rabbit: 3-5kg and 60cm in length.

81

The fox

If you draw a pointed muzzle, upright ears and a bushy tail you've already got a fox, even if the whole thing isn't very red. *Vulpes vulpes* adapts everywhere, even in towns. It lives in the holes of rabbits and badgers and is a great consumer of rodents. It hunts at twilight and at night.

SEPIA

BURNT UMBER

GOLDEN OCHRE

BURNT SIENNA

ORANGE

YELLOW OCHRE

The foxy fox

The red fox gets its common name from its colour. The throat, stomach and end of the tail are white. The back is more brown or fawn. Its coat changes according to the season: redder and thicker in winter, it is darker the rest of the time.

Apart from the size, there is no morphological difference between the male and female. The male is taller, and weighs between 6 and 10kg, a kilo more than the female. To get the proportions right, it is important to know that the tail is almost as long as the body, lighter underneath and white at the end, sometimes with a little black point.

Top of the angular forehead

Border and back of the dark ear tips

Dark or black markings between the eye and the edge of the mouth.

Details of the tail

The fur is darker on the top of the tail.

Pointed muzzle and black nose

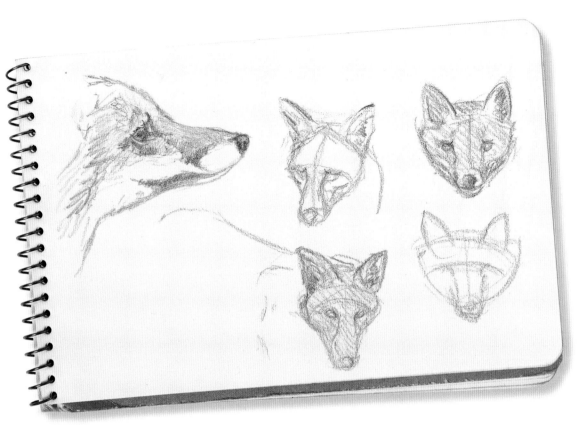

The ears are too long.

This fox is not well drawn: the jaw should be much wider and more powerful. It looks more like a cat.

The tail is not bushy enough at the base.

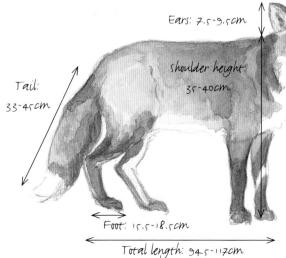

Ears: 7.5-9.5cm

Shoulder height: 35-40cm

Tail: 33-45cm

Foot: 15.5-18.5cm

Total length: 94.5-117cm

The legs and the back are more brown.

To conceal yourself well, here are some basic rules: be as quiet as possible, wearing dark clothes, no perfume or deodorant and unscented suntan lotion. Avoid clothes that rustle or make a noise, minty sweets or chewing gum. If there are several of you, try not to talk: sounds travel far and fast.

83

THE FOREST

Extensive, densely wooded areas abound in small creatures of all sizes. There is always something to draw which the seasons embellish in their turn: sharper colours in springtime and flamboyant reds in autumn. Get out your paintboxes!

A fruit that isn't one

Fragaria vesca is a small, low herbaceous plant. I use watercolour pencils to draw directly, without water, like coloured pencils. I added a little water with a quick dab of the brush on the leaves to tint them.

1 I draw the general shape of the leaf with the central vein.

2 The edge is toothed regularly. I draw the teeth and, with the same pencil, I draw the secondary veins.

3 I pencil lightly, covering the leaf.

4 Then I brush it lightly with a damp brush to unify the ensemble, preferably doing all the leaves at the same time.

In fact, it is not even a real fruit! The fleshy part, that we think of as the fruit, consists of numerous small red spheres containing seeds. Darker when they are ripe, these are the real fruits. !

False fruits oval or round

Green false fruit not yet ripe

Compound trifoliate leaf with toothed edges

5 rounded petals

Akenes (individual fruits)

Each little akene is a fruit.

Runners

False fruit

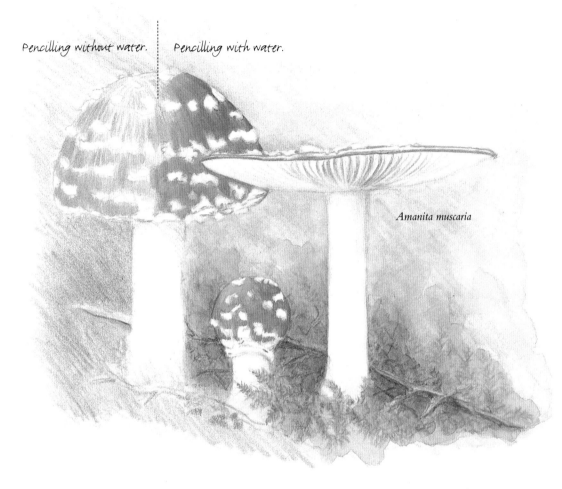

Penciling without water. | Penciling with water.

Amanita muscaria

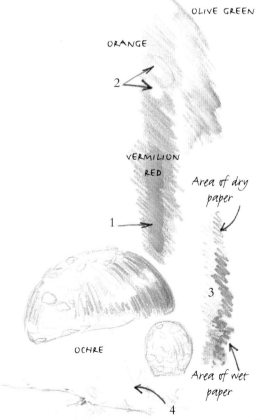

The fly amanita gets its name from the fact that it was used as an insecticide. But be careful: it is also toxic for human beings.

1 The water strongly changes the colour and texture of the pencil.

2 For white, simply don't colour the paper.

3 The difference is striking between the pencil used on dry paper and on wet paper.

4 The stem is white but, to give body, I use an ochre pencil, which enables me to give it definition, marking the shadows and small spots.

OLIVE GREEN

ORANGE

2

VERMILION RED

Area of dry paper

1

3

OCHRE

Area of wet paper

4

The fly amanita

This splendid mushroom is a scarlet jewel dotted with white. Shiny, with a smooth damp texture, it is common and easily spotted. These amanites are often grouped together – a magical discovery.

I draw directly with watercolour pencils. This allows me to postpone working with water. I don't press too hard so that I can rub it out if I make a mistake. In fact, the amount of pigment increases with the number of strokes and the force used by the artist. I pay a lot of attention to how I am using my pencil, covering as evenly as possible for large areas, rounding the lines for curved shapes.

The colours become much more vivid when they are wet. You have to do a test, increasing the amount gradually. But be careful, if the paper does not dry between coats, the pencil will deposit too much pigment.

85

The snowdrop

Galanthus nivalis passes most of its time completely buried in the soil, but it is one of the first perennial bulbs to show the tips of its leaves after the winter. It often flowers in the snow, hence its name. Its single, cone-shaped flower lights up the forest from February to March.

Drawing the snowdrop

I draw the axis of the stem first: that will give me the direction of the whole plant. The ensemble is quite simple, consisting of just two leaves and a stem that carries one flower. The flower is a perfect cone shape and the three external tepals are identical, arranged at an equal distance from each other.

1 I draw an elipse with a reduced width to know where to find the point of the tepals.

2 I apply sap green. Then I gently go over the shadows of the white flowers.

The peduncle of the flower serves as its axis. The flower is framed as a cone composed of 3 sepals on the top and three petals in the form of a corolla.

1

2

Pedicel

3 oblong sepals

3 indented petals

3

3 To make the white flower stand out against the white paper, one must take advantage of all possible shadows on the side opposite the light, and under the tepals. Put on enough pigment to shadow without making it muddy, make the white opaque and outline it.

I use a mixture of sap green and Davy's grey so that the tint is not too grey. A very light touch of green chromium oxide is suitable for the shadowing on the right at the base of the flower as well as for the foliage, which is bluish-green.

Peduncle, about 20cm

spathe

The hollow at the base of the flowers will be accentuated by a little touch of perylene green.

SAP GREEN

DAVY'S GREY

CHROMIUM GREEN OXIDE

2 leaves 4-8mm wide

The base of the leaves is flat.

Think of drawing a bulb from time to time. It is a very good exercise in observation, working with volume and light.

The white is outlined with shadows

Lily-of-the-valley in May

Common except in the Mediterranean, this is found throughout Europe, Asia and North America. It is the symbol of the first of May but, except in florists', it does not always appear on time.

From July to October the flowers are replaced by smooth round fruits, but these pretty red fruits are particularly toxic.

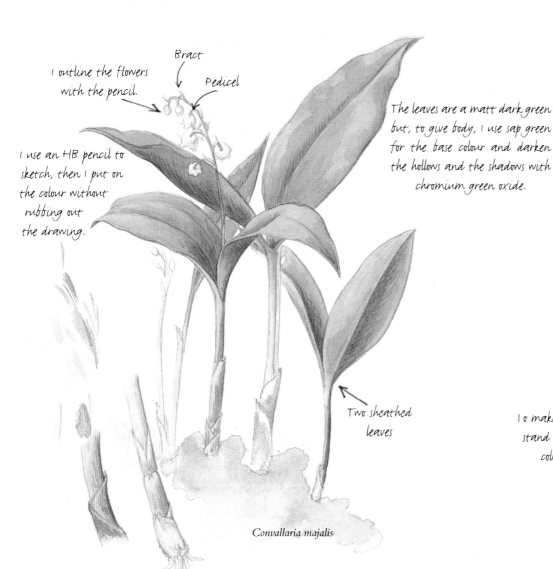

I outline the flowers with the pencil.

Bract

Pedicel

I use an HB pencil to sketch, then I put on the colour without rubbing out the drawing.

The leaves are a matt dark green but, to give body, I use sap green for the base colour and darken the hollows and the shadows with chromium green oxide.

Two sheathed leaves

Convallaria majalis

The white is outlined with pencil.

Profile

Top

Bottom

The flower is an upturned bowl, fixed on the stem which acts as the central axis. I divide this bowl into six equal parts to find the tepals. They are joined at the base and along half their length. The other half reduces to points which turn towards the exterior.

To make the white of the little bells stand out, the quickest way is to colour the paper round about.

The white is outlined with the colour.

87

The purple foxglove

Foxgloves flower all summer until the autumn. They are easily distinguished from afar, because they grow on embankments, and the superb straight standing flower shaft often measures more than 1.20 metres. The tubular flowers, arranged in clusters, can be pink (*Digitalis purpurea*) or white (*Digitalis purpurea alba*). However, other botanical species have different colours.

I observe the young flower buds. They are oval, with a pointed top and a peduncle at the other end.

The leaf stalk and its tendril are distinctive and worth a close look.

The foxglove is a biennial. If you sow seeds, you will have the flowers the following year. So if you plan to draw it, you should take that into account..

CHROMIUM GREEN OXIDE

SAP GREEN

GREENY YELLOW

The leaf has a bubbled appearance which is due to the numerous bumps which cover it. The veins appear in the hollows.

PERMANENT MAGENTA

With annotated observation sketches, details enlarged and colour samples can be done on the spot.

SEPIA, PERMANENT MAGENTA AND PERYLENE MAROON

The general shape of the flower is a cone. Don't lose sight of this shape when placing the shadows and bringing out the body. The central vein helps greatly in positioning the interior shadows.

88

The stages of the drawing

1 I start with a light wash of sap green on all the stems, the leaves and the last buds at the top which are not yet pink. As these two complementary colours muddy each other, I always avoid mixing them unintentionally.

2 Gradually I put in the shadows with chromium oxide. This enables me not to get lost in all these nooks and crannies. I always apply the paint in the direction of the veins.

3 Then I look at the insides of the flowers. The young flowers have spots of bordeaux encircled with pale yellow, while the older ones are more open and the yellow has become white. These spots mainly adorn the lip at the bottom. I start by marking the places that will stay white or yellow with a light pencil.

4 Then I put on a light wash of permanent magenta. When the paper is quite dry, I rub out the pencil so that it will not encircle the white.

5 Finally, always on dry paper, I put in the bordeaux spots with a fine brush and very little water so as not to let it overflow.

6 Everything is in place, now I have to try to get the exact tints. I put on a light wash of sap green, a little stronger, on the stem and the little flower buds, then the shadow with a little chromium green oxide. The leaves have a lighter green chromium oxide and I darken them while keeping the lighter parts which are in sap green.

7 To accentuate the shapes, I add pink magenta on the flowers, between the zones which I have reserved for the parts that stand smooth and shiny.

8 Then, I add Payne's grey with little touches near the attachment, under and in the flower, to mark the shadows. Inside, I pass my brush in the direction of the curve, so marking at the same time the rounding and the hollow of the flower.

9 To finish, with a fine brush I put on a light wash of perylene green to shadow each hollow and each underside of the leaves, especially those at the bottom of the stem, thicker, opaque and falling back.

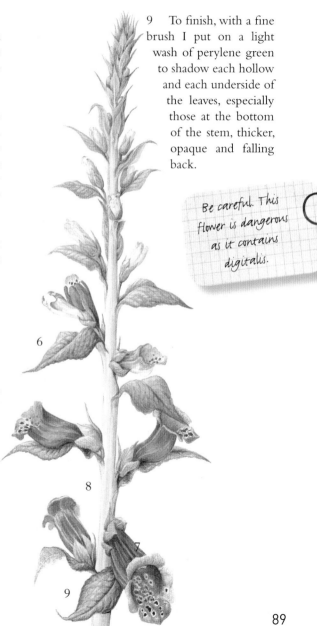

Be careful. This flower is dangerous as it contains digitalis.

The hazel tree

Well known for its nuts, *Corylus avellana* is a little tree, 2-5metres high, widely found in gardens, bordering roads and forests. Whatever the season, it offers something attractive to draw: the leaves, the branches adorned with tender buds, the flowers or the nuts.

Sketching the hazel tree

1 I draw the central vein, and from there the secondary veins. The latter must be well defined, for it is they that are going to constitute the 'bubbling' of the leaves. At the end of each vein is a little point, a bit more developed than the rest of the toothed border. To help with the shape, see page 17 on foreshortening.

2 I apply a light wash of olive green mixed with sap green to colour the whole leaf.

3 The veins are in a hollow. To make them stand out I put on another broad wash of the same colour all along each vein, but on the side away from the light.

4 When the paper has dried a bit more, I apply the same tint with a fine N° 00 brush on each vein to define them better.

5 When the highlights and the veins are placed, I add effects to show the crumpled appearance of the texture. With my N° 00 brush, using olive green and a little water, I draw a little line for each crease I can see.

If it's summer and the tree seems to lack water: the edges of some leaves are starting to turn brown. To show this phenomenon, it is enough to apply an intermediate yellow ochre between the green and the brown of the edge.

6 To finish, I return with the olive green on the shadows that I want darker, in the hollows and inside the curves of the leaf. Then, with a fine brush and a little water, I again go over all the points at the edges of the leaf which are rimmed with sepia.

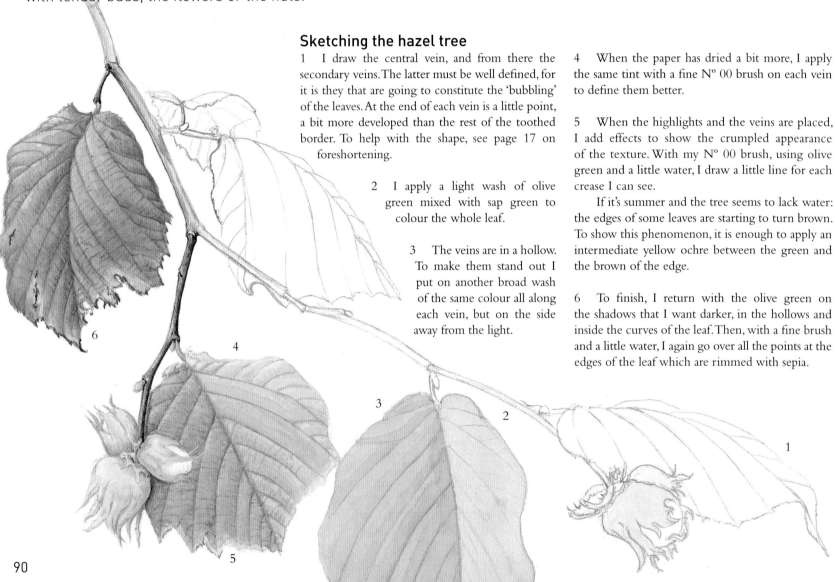

The catkins

The male flowers, known usually as catkins, are large garlands composed of small, box-like flowers fastened to a central vertical axis. This axis makes the framework of the drawing, even if it is not visible until the pollen is ready to fly away.

1 I draw a sausage for the general shape, then the central axis.

2 Visually, the flower 'boxes' turn around the central axis as they go down. To illustrate this effect, I draw parallel lines all leaning in the same direction.

3 Then in pencil I draw each flower 'box' in its place between each line. I then put on light azomethine yellow, adding shadows with yellow ochre and golden green to each flower.

4 When the paper is dry I rub out the pencil and add burnt umber to mark the shadows and so make the light colours stand out more.

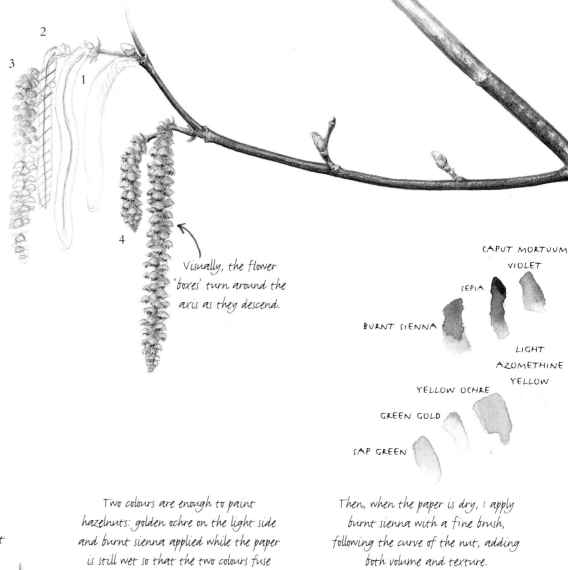

Visually, the flower 'boxes' turn around the axis as they descend.

CAPUT MORTUUM VIOLET

SEPIA

BURNT SIENNA

LIGHT AZOMETHINE YELLOW

YELLOW OCHRE

GREEN GOLD

SAP GREEN

The nuts form a circle, but they are not round: the profile is flatter.

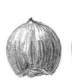

Front view Profile

Two colours are enough to paint hazelnuts: golden ochre on the light side and burnt sienna applied while the paper is still wet so that the two colours fuse and merge into each other.

Then, when the paper is dry, I apply burnt sienna with a fine brush, following the curve of the nut, adding both volume and texture.

The oak

The pedunculate oak, common in all the temperate regions of Europe, is a tree 25-35 metres high and can live to between 500 and 1000 years old. It is known under its latin name *Quercus robur* (meaning strong) or *Quercus pedunculatus* (with a stalk). A long stalk indeed supports the cup which holds the acorn. It is deciduous, so winter is the time when you can draw its great boughs. The oak produces a large quantity of acorns, a source of food for a lot of animals in the forest.

Indian ink technique

This is the technique that is used for botanical illustrations. It needs a lot of information and a table where you can work quietly. The most important point is to know your tools and how to handle them. Practise drawing straight lines, lines that cross, curves, angles… It isn't always easy and sometimes the hand shakes (drink less coffee!). Closing up lines or points, you get darker areas; spreading them out, the effect is lighter.

Choose a pen that suits you, and also the thickness of the point. The thicker the line, the larger the drawing has to be to stay accurate. Personally I use cartridges of Indian ink for pens of 0.10 and especially 0.18, which have less tendency to get blocked up. The line of the cartridge pen is more regular than that of a fountain pen.

Most of the time I draw on any paper. When I am pleased with my sketch, I stick a sheet of tracing paper on top and trace it in ink. There are several qualities of tracing paper: the thicker it is, the more it tolerates errors and scratchings. A quality paper will also last longer.

To correct stains, deletions or imperfections, scratch them out with the help of a rounded scalpel blade. The ink deposited on the tracing paper does not penetrate into the fibres, so it is easy to take off, scratching the paper horizontally and very lightly, so as not to pierce it. After this operation the texture of the paper is changed and becomes porous. To be able to redraw on this area, it is enough to put on a little gum to rewax the paper. I often use this technique of scratching when I want to colour something, like this oak leaf. Even if the points are fine, the quantity of ink put down is the same everywhere, so it is enough to scratch the paper at the areas where I want to add light.

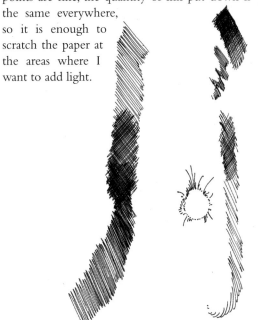

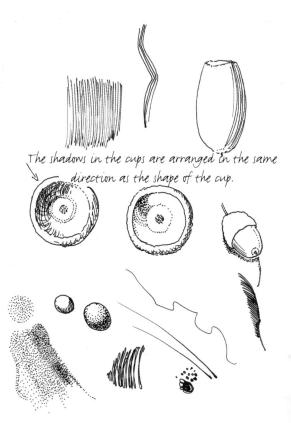

The shadows in the cups are arranged in the same direction as the shape of the cup.

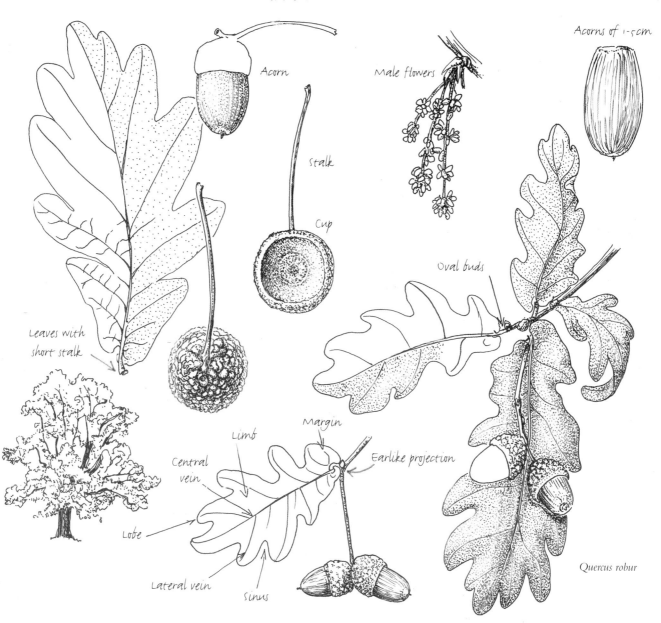

Large stalk of 2-10cm that
carries the acorn.

Acorn

Male flowers

Acorns of 1-5cm

stalk

Cup

Oval buds

Leaves with
short stalk

Margin

Limb

Central
vein

Earlike projection

Lobe

Lateral vein

Sinus

Quercus robur

ANATOMY OF A LEAF

The jay

Apart from the colour, and the beak, which is very strong, the jay very much resembles the crow. It's not worth trying to hide, for this is a very clever corvid. It has already spotted you before you have even seen it.

Sketching the jay

Garrulus glandarius is found in broad-leaved forests, but equally near the edges of woods, near clearings or in parks. This corvid is easily recognised by its bright colours, its long tail and raucous warning cries. It mainly eats acorns, but also eats brood eggs and insects. Jays nest in couples and lay their eggs from April to June.

When it is excited or intrigued, it raises the feathers on top of its head like a speckled crest of black feathers.

Wings turquoise blue with black bands

Underside and breast pinky beige

Back grey brown

White rump

Tail and tips of wings black

shoulder

Marginal coverts

Wrist

Alula

Wing coverts

Elbow

secondary flight feathers

Primary flight feathers

ANATOMY OF A BIRD'S WING

You must make a rapid sketch to place the different colours correctly.

94

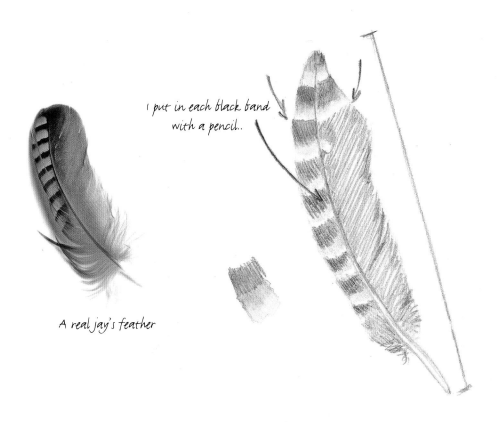

I put in each black band with a pencil..

A real jay's feather

TURQUOISE BLUE

2

3

1

COBALT
BLUE

LIGHT COBALT
BLUE,

4

BLACK

SEPIA

5

6

Painting a feather

If it is difficult get close to a jay, it is fairly common to find one of its pretty little feathers, identifiable above all by the association of the colours, four to be exact, not counting the white. In fact the difficulty consists in being very rigorous and attentive in placing each colour, and in not encroaching on the white paper between the turquoise blue and the black.

1 After having well observed the feather. I draw the shaft and the outline. I place each band of black. using a pencil.

2 I start by applying turquoise blue, light cobalt in little lines. Each time I remember to leave a small band without white above the black.

3 On the still wet paper I add blue cobalt above the turquoise so that the two blues mix where they meet to form a gradation.

4 Once the paper is dry, I add the black with very little water so that it will not run over.

5 On the shaft and the barbs I put a sepia tone to proved a contrast to the black.

6 The part of the feather that is greyish will be tinted with diluted black or by pencil on dry paper (6HB).

Woodpeckers

Woodpeckers are climbing birds. Out of the many varieties I have chosen to show three: the green woodpecker (*Picus viridis*), the great spotted woodpecker (*Dendrocopus major*) and the middle spotted woodpecker (*Dendrocopus medius*), a European woodpecker, and the smallest of the three.

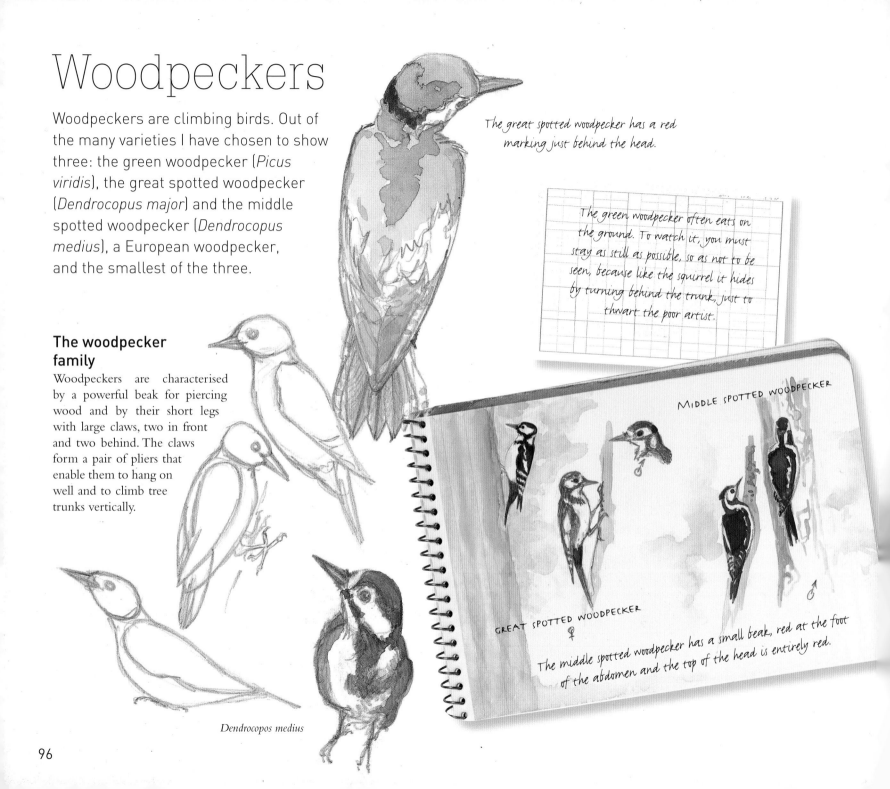

The great spotted woodpecker has a red marking just behind the head.

The green woodpecker often eats on the ground. To watch it, you must stay as still as possible, so as not to be seen, because like the squirrel it hides by turning behind the trunk, just to thwart the poor artist.

The woodpecker family

Woodpeckers are characterised by a powerful beak for piercing wood and by their short legs with large claws, two in front and two behind. The claws form a pair of pliers that enable them to hang on well and to climb tree trunks vertically.

Dendrocopos medius

MIDDLE SPOTTED WOODPECKER

GREAT SPOTTED WOODPECKER ♀

The middle spotted woodpecker has a small beak, red at the foot of the abdomen and the top of the head is entirely red.

♂

96

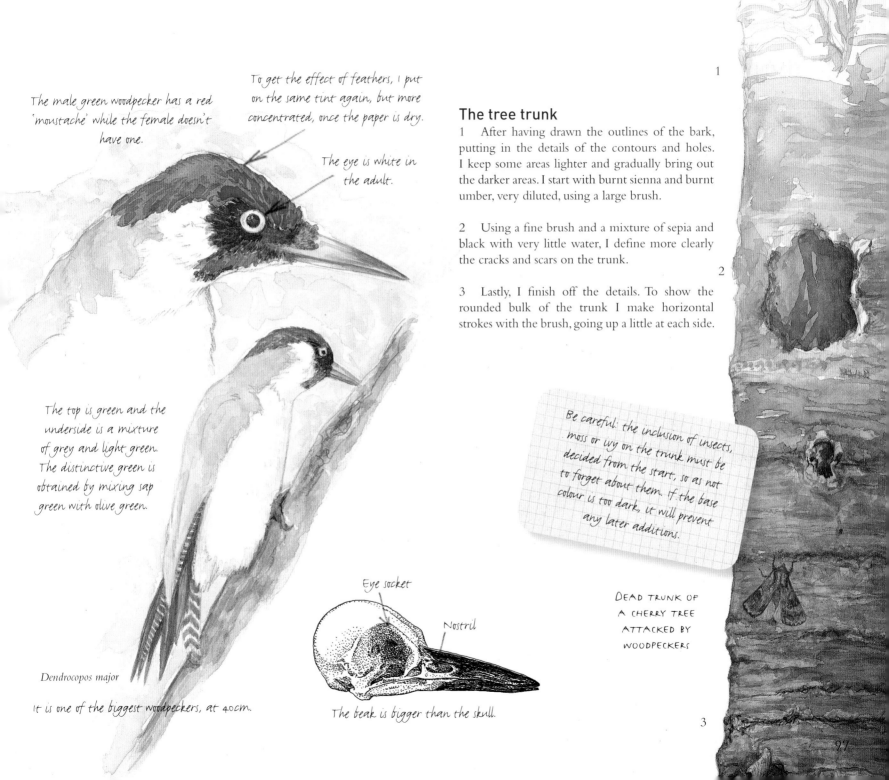

The male green woodpecker has a red 'moustache' while the female doesn't have one.

To get the effect of feathers, I put on the same tint again, but more concentrated, once the paper is dry.

The eye is white in the adult.

The top is green and the underside is a mixture of grey and light green. The distinctive green is obtained by mixing sap green with olive green.

Dendrocopos major

It is one of the biggest woodpeckers, at 40cm.

Eye socket

Nostril

The beak is bigger than the skull.

The tree trunk

1 After having drawn the outlines of the bark, putting in the details of the contours and holes. I keep some areas lighter and gradually bring out the darker areas. I start with burnt sienna and burnt umber, very diluted, using a large brush.

2 Using a fine brush and a mixture of sepia and black with very little water, I define more clearly the cracks and scars on the trunk.

3 Lastly, I finish off the details. To show the rounded bulk of the trunk I make horizontal strokes with the brush, going up a little at each side.

Be careful: the inclusion of insects, moss or ivy on the trunk must be decided from the start, so as not to forget about them. If the base colour is too dark, it will prevent any later additions.

DEAD TRUNK OF A CHERRY TREE ATTACKED BY WOODPECKERS

1

2

3

The tawny owl

Strix aluco is one of the most widely distributed owls in Europe, unlike the barn owl, which is in the process of disappearing. This splendid night hunter, about 40 cm, hunts blind, thanks to its extremely sharp hearing. So be careful if you want to see it – no noise!

A very attractive bird

Quite settled, it frequents forests, parks and cemeteries and nests in hollow tree trunks or old stone walls. Couples nest from March to June, often in the same place every year. You can watch them easily while nesting, by constructing a hide. But look closely, for at rest its protective covering is very efficient. Though the owl is usually brown, its colour is extremely variable from one to another, and can go from dark browny-red to light grey. There is no difference between males and females. You have to sketch nocturnal hunters in daylight whenever they are visible, taking maximum advantage of the times when they are quietly at rest.

Drawing in blood red

These sketches are made in blood red pencil. I find this dry technique very practical in the wild, for it only needs a pencil and a sharpener. Very light and easy to transport, but the pencil doesn't break, like chalk. Moreover, the red tint gives a certain cachet to the drawing.

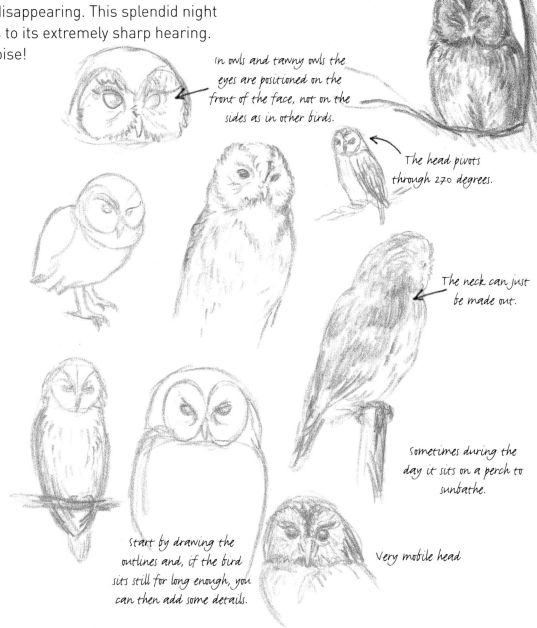

In owls and tawny owls the eyes are positioned on the front of the face, not on the sides as in other birds.

The head pivots through 270 degrees.

The neck can just be made out.

sometimes during the day it sits on a perch to sunbathe.

Start by drawing the outlines and, if the bird sits still for long enough, you can then add some details.

Very mobile head

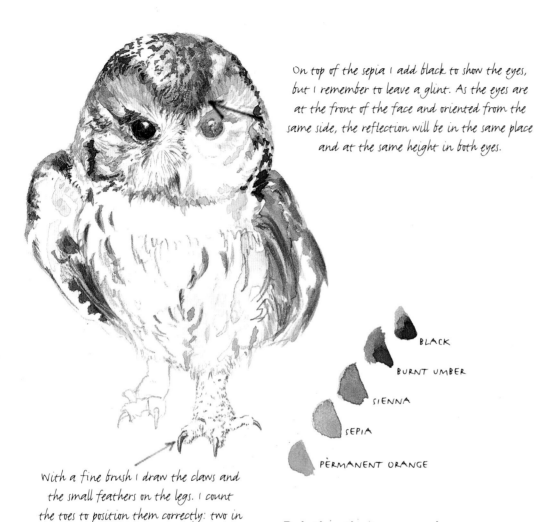

On top of the sepia I add black to show the eyes, but I remember to leave a glint. As the eyes are at the front of the face and oriented from the same side, the reflection will be in the same place and at the same height in both eyes.

With a fine brush I draw the claws and the small feathers on the legs. I count the toes to position them correctly: two in front and two behind.

BLACK

BURNT UMBER

SIENNA

SEPIA

PERMANENT ORANGE

How do you recognise the feather of a nocturnal hunter? Shake it in the air – it makes no noise.

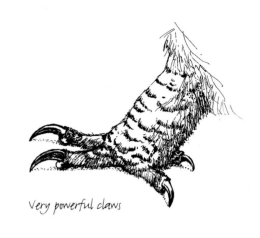

Very powerful claws

I drew this wing feather very quickly in ochre and sepia watercolours. Once the paper was dry I outlined it with a fine black felt-tip, to refine it, and give more definition.

Painting the tawny owl

After having made a sketch and decided on the placement of the various colours, I start with permanent orange, for this owl is quite orangey. It is a little bright, so I mix it with a some sepia to tone it down. I next put on sienna, then burnt umber. I always make my brush stroke in the direction of the feathers.

I use a light sepia wash to shadow under the wings and the last dark feathers.

The red squirrel

The squirrel is very lively and so curious that it is easy enough to attract it with treats such as walnuts or hazelnuts. It can become quite familiar, sufficiently to be observed.

What style!

Sciurus vulgaris is so quick that you must adapt, taking advantage of each instant there is to sketch as quickly as possible. The position of its tail, stretched out, curled up on its back or lying on the ground, is a good indicator of its mood. It measures 35-45cm, the tail accounting for half of that. The colour varies with the individual and the season, in a spectrum that goes from light russet to dark brown in summer, but the stomach is whiter. In winter the fur is longer, especially on the tips of the ears.

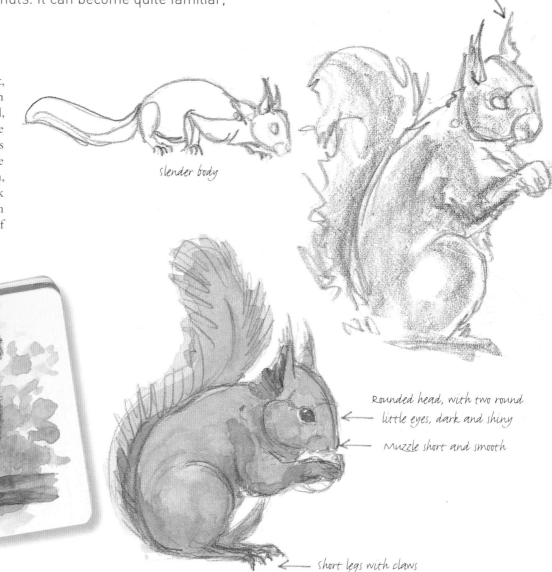

Ears erect

slender body

Rounded head, with two round little eyes, dark and shiny

Muzzle short and smooth

short legs with claws

How to sketch the red squirrel

To sketch quickly, you must start with the rounded shape of the head and then draw the vertebral column from the head to the end of the tail. Once you have drawn this stance, find the articulation of the shoulders and the haunches, and then the legs. Then, if the squirrel has not disappeared, add the details: the pointed nose, the round eyes, the ears and the paws. An orange wash can tint the ensemble, except for the stomach, which stays white.

To show the fur, it is enough to apply a base colour and add the hairs one by one, from lighter to darker in watercolour, and from darker to lighter in gouache (see p.25). The tail, very fluffy, is even more so in winter.

The young, recognisable by their big heads and long legs, are clumsy and playful.

When you are near squirrels, avoid making any sudden movements which could seem aggressive or threatening. Crouch down, to be less frightening. With experience, you will find out how near the squirrel will let you come before it flees.

Test patch to check the amount of water and the right tone of pigment.

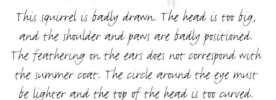

This squirrel is badly drawn. The head is too big, and the shoulder and paws are badly positioned. The feathering on the ears does not correspond with the summer coat. The circle around the eye must be lighter and the top of the head is too curved.

THE MOUNTAINS

The flora and fauna of the mountains have adapted to this wild environment. The plants have a short life cycle, and hurry to flower in order to reproduce. If they are often small and simple, they compensate by using their magnificent display to attract pollinators. Most mountain animals are not visible in winter; some hibernate and others descend lower to take advantage of higher temperatures and more abundant fodder. You too will have to adapt to sketch them more easily.

A multitude of golden yellow stamens adorn the inside of this flower. The contrast between these two opposing complementary colours, yellow and violet, produces a most luminous effect.

For the flower, manganese violet.

The stem, and the back of the six petals, are covered with little hairs.

For the hairs, a little Davy's grey mixed with chromium green oxide. These very fine hairs are executed with a No 00 brush. They must stay light and a little transparent.

For the foliage, chromium green oxide.

Pulsatilla vulgaris

To try out tints on the spot, three colours are enough.

The general outline is bowl-shaped, with a central axis for the stem.

VIOLET

MANGANESE VIOLET

OLIVE GREEN

SAP GREEN

AZOMETHINE YELLOW

The Pasque flower is mauvish and flowers from April to May. It grows below 1,000 metres of altitude. Be careful, because in spite of its beauty it is very toxic!

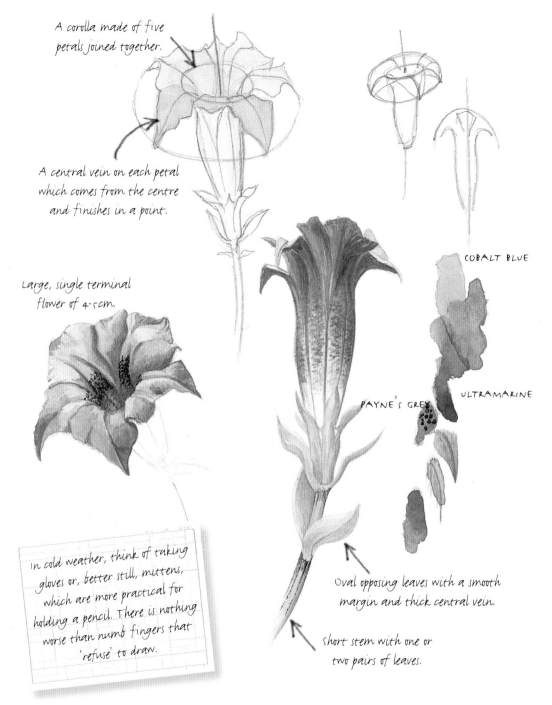

A corolla made of five petals joined together.

A central vein on each petal which comes from the centre and finishes in a point.

Large, single terminal flower of 4-5cm.

COBALT BLUE

PAYNE'S GREY

ULTRAMARINE

In cold weather, think of taking gloves or, better still, mittens, which are more practical for holding a pencil. There is nothing worse than numb fingers that 'refuse' to draw.

Oval opposing leaves with a smooth margin and thick central vein.

Short stem with one or two pairs of leaves.

Clusius's gentian

This must not be confused with *Gentiana lutea*, the yellow gentian, which has the same common name but bears no resemblance, and whose roots are used to flavour a liqueur.

This one, *Gentiana clusii*, is a quite rare little plant, but it can be seen in the Alps, the Pyrenees, the Cevennes and Franche-comté between March and July, when it produces a large blue flower that opens in fine weather.

The rest of the time it is scarcely visible, as it measures 5-10cm and merges into the surrounding vegetation. Clusius's gentian prefers a limestone soil, between 500 and 2,800 metres altitude. This plant is smooth, but on the other hand, in the corolla, you can see round protuberances, navy blue, almost black.

Once the drawing has been roughed out and the structure established, the light areas found and reserved, it remains for me to find some good blues: the base colour, a darker one for showing body, and another for marking the shadows. I choose cobalt blue for the base wash and ultramarine for the small areas of body. As the colour is intense in certain places, I load it with pigment which I apply in several coats so as not to saturate the paper. For the shadows I choose Payne's grey, which is more blue than grey. It is the variation in these three colours, added to the white of the paper, that brings out the contours of the flower.

Edelweiss

In its natural state this legendary plant normally lives at 1,200 to 3000 metres. It is found at the summits of the Pyrenees, the Alps and the Carpathians, and in the Balkan peninsula, but these here grew in the Alpine garden of the Museum of Natural History in Paris. In the mountains edelweiss is rather skimpy and scarcely measures more than 3cm, but while cultivated, it can reach 20cm.

The edelweiss symbolises purity and love. To prove his worthiness and his devotion, the fiancé gathers a bouquet of it for when he makes his marriage vows. This custom, and picking too much of it, has almost succeeded in making it disappear. So, don't pick it!

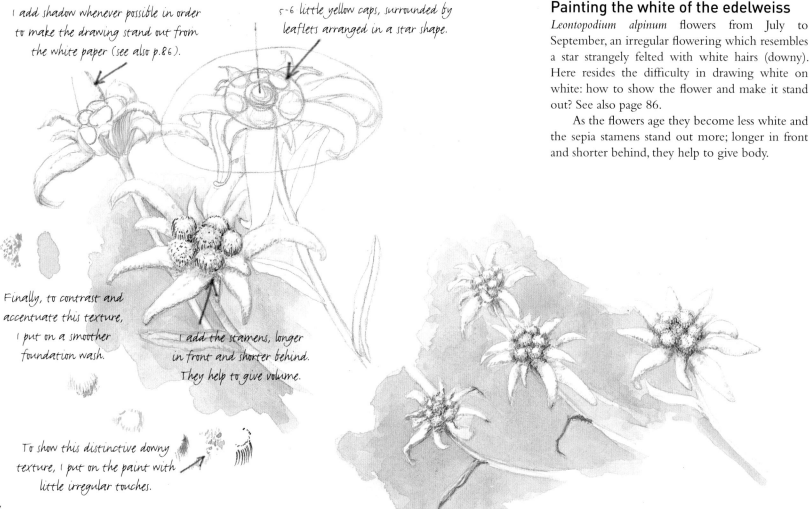

I add shadow whenever possible in order to make the drawing stand out from the white paper (see also p.86).

5-6 little yellow caps, surrounded by leaflets arranged in a star shape.

Finally, to contrast and accentuate this texture, I put on a smoother foundation wash.

I add the stamens, longer in front and shorter behind. They help to give volume.

To show this distinctive downy texture, I put on the paint with little irregular touches.

Painting the white of the edelweiss

Leontopodium alpinum flowers from July to September, an irregular flowering which resembles a star strangely felted with white hairs (downy). Here resides the difficulty in drawing white on white: how to show the flower and make it stand out? See also page 86.

As the flowers age they become less white and the sepia stamens stand out more; longer in front and shorter behind, they help to give body.

The bee orchid

We can distinguish the different *Ophrys* thanks to their shape and the colour of their lips, but individually there is a great variation which often make identification difficult. You have to acquire a book with good photographs or a good plant guide if you want to identify your models correctly.

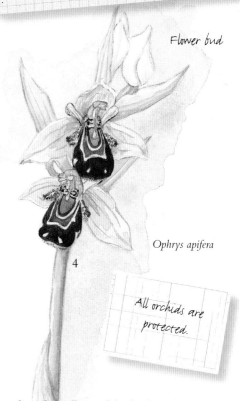

Apifera, or Bee Orchid, means 'I carry the bee' (from the latin apis, meaning bee, and fero, I carry). Each orchid mimics a female bee. It takes on the shape, colours and scent to trick the males who, attempting to mate, ensure the pollination of the orchid.

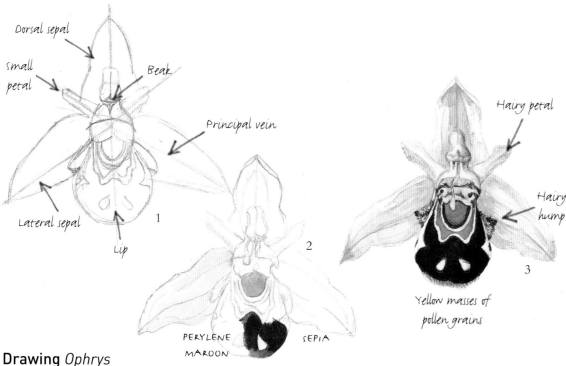

Dorsal sepal

small petal

Beak

Principal vein

Lateral sepal

Lip

1

2

PERYLENE MAROON

SEPIA

Hairy petal

Hairy hump

3

Yellow masses of pollen grains

Flower bud

4

Ophrys apifera

All orchids are protected.

Drawing *Ophrys*

This species, *Ophrys apifera*, flowers from April to July and is found at 1,000 metres altitude. It grows in full sun and in semi-shade, always on limestone, on meadows, scrubland etc. If the flower resembles a bee-shaped sabot it is an illusion, as the lip is convex, not concave.

1 I draw the structure which is symmetrical, with three large sepals. Once all is in place, I dab the pencil on all the areas that will have yellow.

2 I start with light azomethine yellow so as not to forget it, then, on the lip, I use perylene maroon which is quite red, and I put it on in little lines, following the shape, to give the velvety texture. Lastly, using the same method, I add sepia to darken the concave borders. For the sepals, I apply a light pink wash and, for the main veins, sap green.

3 I outline the yellow of the beak with green to give body; I add maroon hairs on the humps and orange on the petals.

4 On the whole plant we can see white buds, and the dorsal sepal which folds towards the back. The sloping stalk is rendered in sap green.

The mountain pine

Widespread in the mountains of Europe, this attractive pine grows between 1,000 and 2,000 metres. It is a shrub that rarely grows more than 3 metres in height. The bark is a browny grey and it is covered with dark green leaves grouped in twos, called needles. The needles last several years on the plant, giving it an evergreen appearance, even in winter.

Painting a detail of the mountain pine

To illustrate a collection of needles, you need to draw each one of them and at each crossover, understand if it is from the foreground pair, the background, the further back pair etc. This is what gives body to the ensemble. The top needles of the pair are slightly bigger and darker.

To show the needles, you have to know that they are thin, attached in twos and measure 4–8cm. After having made the drawing, I colour them with sap green which I leave on the ends, and I darken the rest with chromium green oxide.

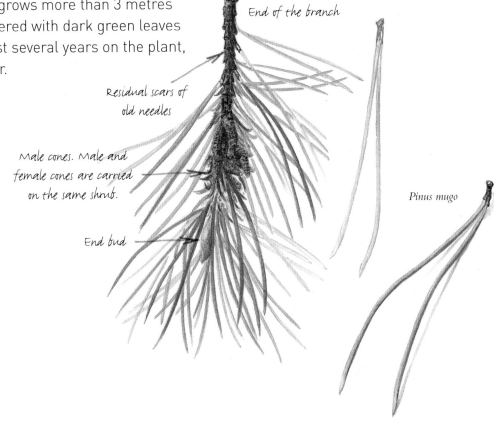

End of the branch

Residual scars of old needles

Male cones. Male and female cones are carried on the same shrub.

End bud

Pinus mugo

A view of the whole bush is easy to sketch. It is not even necessary to make a diagram before painting.

Painting a view of the whole

I work directly, without a preparatory sketch.

1 Use a wash of sap green for the whole.

2 The general tint is much darker, but the young branches are a tender green and sap green serves as a base for darkening. I apply chromium oxide in little touches with a fine brush, to simulate the needles.

The pine cone

1 It is a female cone, the organ that carries the seeds. The scales are fixed on a central axis: the spine. When the seeds are ripe, the scales spread out starting at the bottom to allow the winged seeds to fly off. I draw the central axis, then the contours of the pine cone. The organisation of the scales is complex and precise – I don't want to get lost. So that it doesn't move, I stick it on a piece of cardboard.

2 The scales are aligned in a spiral, following the Fibonacci sequence. A regular spiral, clockwise, which crosses an identical spiral in the opposite direction, creating a square pattern. In each box of this pattern is a scale.

3 The scales at the bottom are spread out – I take note of this when drawing them one by one.

4 I apply a light wash of umber on the whole pine cone and I go over each stalk of the scales with sepia. The more one looks into the interior of the cone, the less light there is. I darken again with sepia.

5 I take advantage of each crack or mark on the exterior faces of the scales to give body by darkening with sepia. Equally, I put it on the whole side of the cone which is opposite the light; as I would for a sphere.

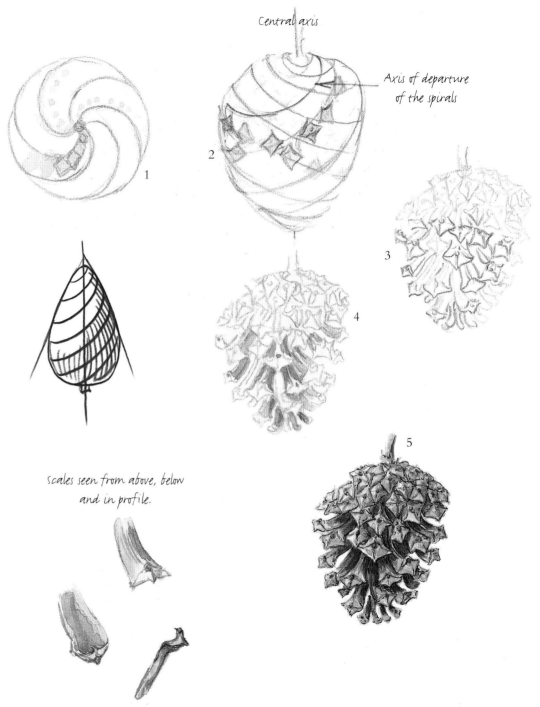

Central axis

Axis of departure of the spirals

1

2

3

4

5

scales seen from above, below and in profile.

107

The marmot

This large rodent of the squirrel family lives in the mountains and hides in burrows at the least sound. You must therefore approach them quietly, making no sudden movements which could be taken as aggressive. According to their experience with any previous humans that they have encountered, they will allow you to approach more or less near, but in any case please keep a reasonable distance.

A large dormouse

Before hibernating in its burrow, the marmot stocks up with fat, which is what gives it a stocky appearance, reinforced by its short legs. You can no longer see the connection between the joints, but you can guess at the rounded shape of the shoulders, the haunches and the elbows. Your drawing will therefore be a little different according to whether you sketch in the spring, or just before winter.

In the mornings, marmots like to sunbathe, and are therefore easy to sketch with a black lead pencil. Take advantage of this to capture some different poses.

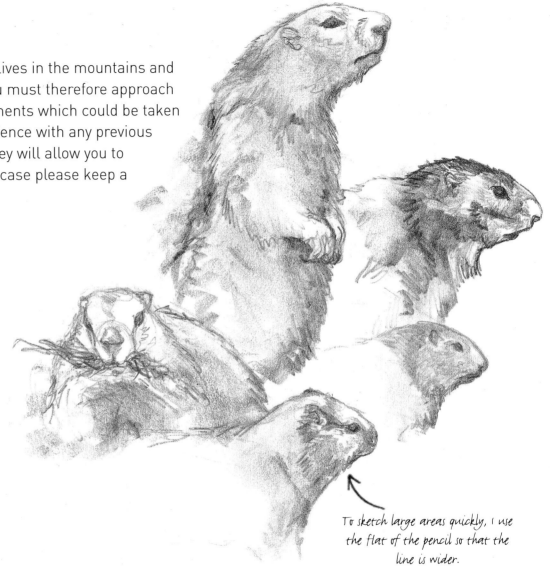

The proportion between head and body is different in the young: the head represents a third of the animal.

To sketch large areas quickly, I use the flat of the pencil so that the line is wider.

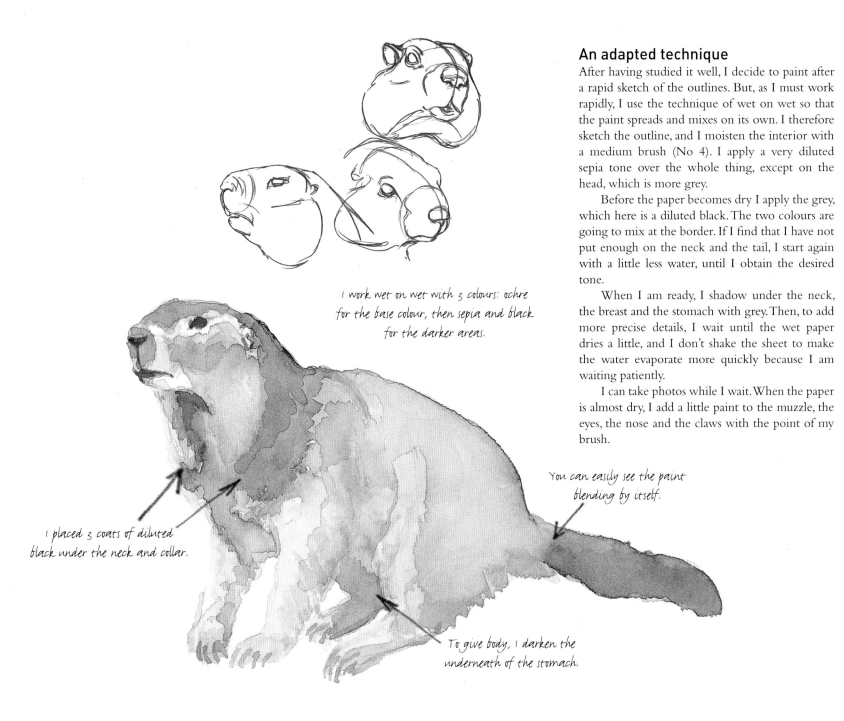

An adapted technique

After having studied it well, I decide to paint after a rapid sketch of the outlines. But, as I must work rapidly, I use the technique of wet on wet so that the paint spreads and mixes on its own. I therefore sketch the outline, and I moisten the interior with a medium brush (No 4). I apply a very diluted sepia tone over the whole thing, except on the head, which is more grey.

Before the paper becomes dry I apply the grey, which here is a diluted black. The two colours are going to mix at the border. If I find that I have not put enough on the neck and the tail, I start again with a little less water, until I obtain the desired tone.

When I am ready, I shadow under the neck, the breast and the stomach with grey. Then, to add more precise details, I wait until the wet paper dries a little, and I don't shake the sheet to make the water evaporate more quickly because I am waiting patiently.

I can take photos while I wait. When the paper is almost dry, I add a little paint to the muzzle, the eyes, the nose and the claws with the point of my brush.

I work wet on wet with 3 colours: ochre for the base colour, then sepia and black for the darker areas.

You can easily see the paint blending by itself.

I placed 3 coats of diluted black under the neck and collar.

To give body, I darken the underneath of the stomach.

Chamois, ibex, mouflon

These animals are found in the mountains of central Europe, the Pyrenees and the Alps. Hunting, the reduction of their habitat and the rigours of winter do more damage than the natural reduction in the wild.

The chamois

These mammals are easy to find, colonising several different areas. In winter they come down from the mountains to graze in the forests or the plains. The Rupicapra rupicapra resembles a goat in build. Quite slender, they measure 70-85cm at the withers and weigh 25-50kg, sometimes more for the male, which is the only difference between the male and the female. The head is characterised by its cheeks and white nose, but above all by a brown-black mask which runs as far as the nose. The coat is browny-russet on the back, while the legs and the lower flanks are brown. In winter the hair is longer and thicker, and the brown becomes almost black.

While the females group together in herds, the male lives alone from June to October, when he rejoins the herd for the mating season.

The horns are in the shape of hooks.

Once the drawing has been done, I apply a quick sepia wash and a second coat, less liquid, to darken the mask.

The pupil, as in all goats, is rectangular and horizontal.

The ensemble is quite symmetrical and a central line could divide the head in two.

Mouflon

Ibex

Chamois

The withers is the highest point of the shoulders. It serves as a point of reference for all animals, when measuring their height from the ground.

Tail

This skeleton is a framework for the whole goat family. To adapt it for each species all you have to do is change the height at the withers, adapt the horns and add a goatee beard for the ibex.

Be careful at mating time from December to mid-January. Some males can be aggressive, so approach with caution.

The ibex

The ibex, *Capra ibex*, is bigger. It measures 70-90cm at the withers and weighs up to 120kg. The males, much stronger than the females, have very well developed horns which can weigh up to 6kg. The ibex is active in the early morning and late evening, before nightfall. It stops during the day to ruminate.

I find that sepia is very suitable for this kind of animal. For contrast or stronger tones, let it dry well between each coat.

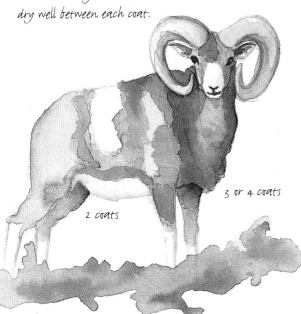

2 coats

3 or 4 coats

The males are easier to observe during the mating season.

A black lead pencil with a bevelled edge gives a dynamic feel to the drawing. You have to draw quickly, with no rubbing out. It is ideal for a quick sketch.

Capra Ibex

A well-proportioned preliminary drawing will help you to make rapid sketches on the spot.

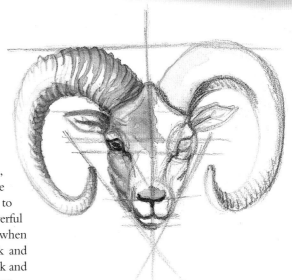

The mouflon

Ovis ammon is the ancestor of the sheep and looks quite like one. The male, which weighs 35-55kg, has impressive horns, while the female, who weighs 25-40kg, has none. It is found mainly in Corsica, Sardinia and various regions of Europe where it has been introduced for hunting, such as the Massif Central, the Pyrenees and northern Provence.

Like the chamois and the ibex it belongs to the goat family. The skeleton corresponds, but be careful: it has to be adapted because the mouflon is more stocky. Don't forget to note its massive frame and especially its powerful hindquarters which enable it to pull itself up when climbing in the mountains. The coat is black and russet with a large white marking on each flank and under the abdomen. In winter, the coat is darker.

Glossary

Amphibian Cold-blooded vertebrate, usually living on land but breeding in the water. The larvae (tadpoles) undergo metamorphosis into the adult form. Includes newts and salamanders, frogs and toads.

Biennial Describes a plant that takes two years to complete its life cycle. The first year it develops and stores reserves; the second year the plant flowers, produces seed and then dies.

Birds of prey Order of birds that hunt others for food, distinguished by powerful talons and a hooked beak.

Botanist Scientist who studies nature through the study of plants.

Conifer Any gymnosperm tree or shrub, typically bearing cones (like the fir cone) and evergreen leaves. The cone can be small and fleshy, as in the yew or the juniper.

Fauna All the animal life of a given place or country, especially when distinguished from the plant life.

Flora All the plant life of a given place or country.

Fructification All fruit from the development of a flowering.

Hide A concealed spot, disguised to look like the natural environment, used by hunters and birdwatchers.

Juvenile State preceding maturity; not yet showing the characteristics of the adult

Margin External border of some organisms, such as leaves

Naturalist Person who has scientic qualifications in, or is interested in, botany or zoology

Plastron Bony plate forming the ventral part of the shell of a tortoise

Reptiles Grouping of cold-blooded vertebrates including tortoises, snakes, lizards, crocodiles etc.

Sexual dimorphism The occurrence in an animal species of two distinct types of individual, male and female

Spiral Plane curve formed by a point winding about a fixed point at an ever-increasing distance from it.

Taxidermist Person who prepares, stuffs and mounts animal skins so that they have a lifelike appearance.

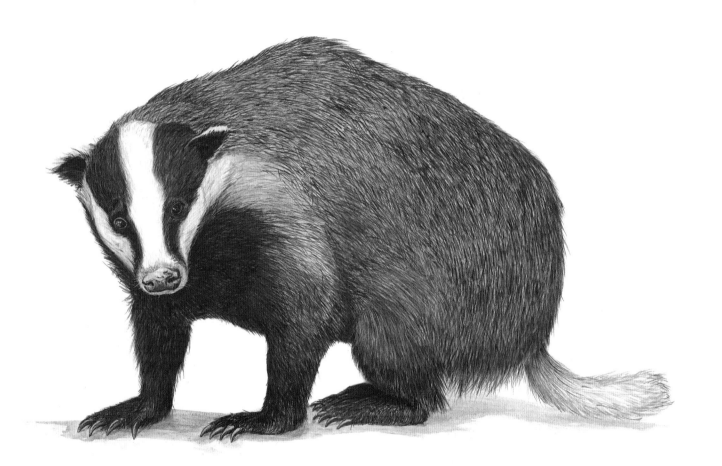

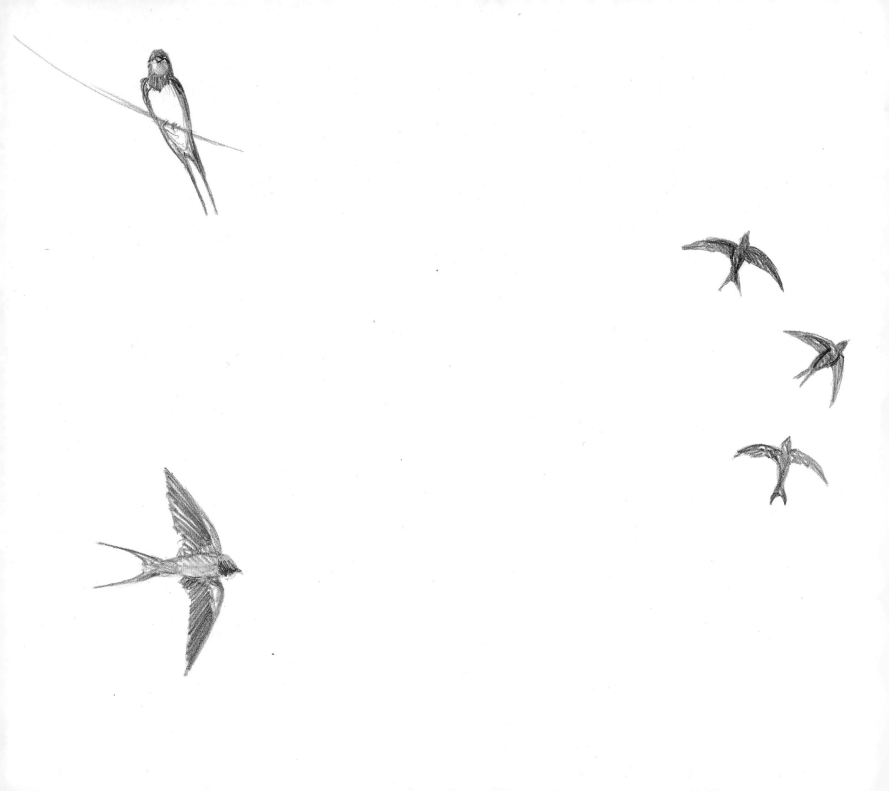